HARVARD MIDDLE EASTERN MONOGRAPHS
XXV

Women's Autobiographies
·in·
Contemporary Iran

Afsaneh Najmabadi
EDITOR

William Hanaway
Michael Hillmann
Farzaneh Milani

DISTRIBUTED FOR THE
CENTER FOR MIDDLE EASTERN STUDIES
OF HARVARD UNIVERSITY BY
HARVARD UNIVERSITY PRESS
CAMBRIDGE, MASSACHUSETTS
1990

Copyright © 1990 by the President and Fellows of Harvard College
ISBN 0-932885-05-5
Library of Congress Catalog Card Number 90-081298
Printed in the United States of America

Acknowledgments

This collection of essays represents the proceedings of a seminar held at the Center for Middle Eastern Studies at Harvard University on May 6, 1988. The seminar was the third in a series on "Biographies and Autobiographies: Presentation of the Self in Iranian Nineteenth–Twentieth Century History," sponsored by the Iranian Studies Program at the Center. As a fellow of the program during the 1987–88 academic year, I would like to thank Professor Roy Mottahedeh, Director of the Center, for making the program and the seminars possible. I would also like to thank Virginia LaPlante and Diane Levy for their editorial assistance.

<div style="text-align: right">Afsaneh Najmabadi</div>

A Note on the Authors

William Hanaway is currently Associate Professor of Persian at the Department of Oriental Studies, University of Pennsylvania. Michael Hillmann is Professor of Persian at the Department of Oriental and African Languages and Literature, The University of Texas at Austin. Farzaneh Milani is Assistant Professor of Persian at the Division of Oriental Languages, University of Virginia. Afsaneh Najmabadi is Assistant Professor of Sociology at the Department of Sociology, Wellesley College.

Contents

I	Veiled Voices: Women's Autobiographies in Iran FARZANEH MILANI	1
II	A Different Voice: Taj os-Saltaneh AFSANEH NAJMABADI	17
III	An Autobiographical Voice: Forugh Farrokhzad MICHAEL CRAIG HILLMANN	33
IV	Half-Voices: Persian Women's Lives and Letters WILLIAM HANAWAY	55

Notes

· O N E ·

Veiled Voices:
Women's Autobiographies in Iran

FARZANEH MILANI

Have you ever tried to look at yourself in running water? The reflection is dim, diffuse. It is vague. It is you but not quite so. It is your image, your double but in a rather scattered way. The outlines are almost familiar but the details are blurry. The image is twisted, distorted, spread out. Now flattering, now disfiguring, now formed, now deformed, it ceaselessly changes. Like the self, it is protean, often fleeting, frequently dispersed.

This analogy expresses the inherent limits of autobiographic narrative, the elusiveness and perhaps even fictiveness of any drive toward textual self-representation. After all, it is symbolically significant that we can see anything and anyone within our field of vision, but we can never see ourselves completely. Captive of images, illusions, and words; standing as the observer and the observed, the narrator and the narrated, the creator and the created; subject all the while to the temporal stream—the autobiographer has the quixotic task of reconciling the otherwise irreconcilable.

It is nevertheless autobiography which generically claims more explicitly than any other literary form to embody the correspondence between the writing and the writer. Autobiography, one is led to believe, is an attempt to represent the self through writing. It is the favorite literary pastime of modern

Western man and, in the words of James Olney, "the commonest" of all literary enterprises these days.[1]

Yet Iranians, who have been fascinated with Western literary traditions for the last hundred and fifty years, have basically turned their backs on autobiography. Paradoxically, if autobiographies are expected to offer a certain self-reflexivity, whereby the self is a problem unto itself and thinks about itself, Persian literature abounds in that feature. Sufism, or Islamic mysticism, not only allowed radical breaches of public convention and formality but also demanded intense forms of self-meditation. If autobiographies are expected to provide a certain self-glorification and self-congratulation, then again Persian literature contains a generous supply of that mode of discourse. *Rajaz-khani*, for instance, is the ritualized boasting of heroes in epics, and the *takhallos* tradition allows for the poet's open expression of self-praise and self-satisfaction. Despite these traditions, Iranians have suppressed or subverted the uninhibited, unformulaic, public disclosure of self.

Many factors may have contributed to the paucity of this literary genre. Its absence is perhaps the logical extension of a culture that creates, expects, and even values a sharply defined separation between the inner and the outer, the private and the public. Perhaps it bespeaks a mode of being and behavior that is shaped, or misshaped, by varying degrees and types of censorship, both external and internal. In short, it could be one more manifestation of strong forces of deindividualization, protection, and restraint.

"Save face," "protect appearances," "keep the face red with a slap," and many more common proverbs are still in abundant use and practice in Iran. These proverbial admonitions highlight the overriding concern for maintaining respect and self-respect. Shame rather than guilt is a major consideration, explaining in part why there is no tradition of confession, in either its catholic

sense or its secular, modern counterpart of psychotherapy. In fact, both practices are considered less as means of gaining relief than of courting trouble by exposing the inner self, which preferably should remain shielded and sheltered, to be revealed only to the angels Nakir and Monker after death. A red tongue, *Zaban-e sorkh*—the fiery kind, the kind that is not totally under control—gives heads away. After all, Hallaj, the great Sufi martyr of the tenth century, was executed for publicly announcing his views, loud and clear, for everyone to hear. Small wonder, then, if Hazrat Ali, the first imam of shi'ites, talks to a well, if Rostam, the epic hero, confides in his horse, if Dash Akol, the embodiment of manliness in Sadeg Hedayat's story of the same name, confesses to his parrot, and if Naser ed-Din Shah, who reigned in 1848–1896, chats with his cat, while countless others find solace in talking to *sang-e sabur* (the patient stone) or to the shrines of imams and holy saints.

No self-concealment, however, can be complete or permanent. Perhaps the harder the individual's attempt to conceal the self and to deflect intrusions, the stronger the impulse of the society at large to uncover and expose what it considers private. The restriction on open verbal disclosure increases the need for alternative mediums of communication: eyes pry, penetrate, infiltrate; mouths compulsively rumorize; crows turn into gossip mongers, unruly tattle-talers; and walls—those armors for protection—grow ears. After all is it not true that walls have mice and mice have ears?

The ideal Islamic state, for men and women alike, is a covered one. From the viewpoint of Islam, clothing is not to display the body. It is to conceal, to hide, and to reduce sexual enticement. Even in the Islamic paradise men and women are not naked but properly covered. The Qur'anic story of the Fall from the Garden of Eden best exemplifies the fact that the Islamic paradisical state is a covered one. Upon eating from the forbidden tree,

Adam and Eve were punished by being exposed to one another. Nakedness was a punishment for them, as it continues to be today for their Muslim sons and daughters. Congruently, the Persian word *pushidan* (to dress) means to cover up, to conceal from view, whereas the English term means, among other things, to decorate, to adorn.

By the same token that autobiographies are a conspicuously lacking commodity, women, who have been deliberately, if not obsessively, kept away from the arena of public life and discourse, have a still more restrained relation to public self-representation. From Leyli, the conventional beloved of classical literature, to the poet Forugh Farrokhzad (1935–1967), the unconventional lover of modern literature, women have lamented the restrictions placed upon their personal expression. Leyli openly deplored the imposed image and silence foisted upon her: "He is a man, I am a woman! . . . He can talk and cry and express the deepest feelings in his poems. But I? I am a prisoner. I have no one to whom I can talk, no one to whom I can open my heart: shame and dishonour would be my fate."[2] Centuries and many suppressed voices later, Farrokhzad can reiterate the same grievance: "I wanted to be a 'woman,' that is to say a 'human being.' I wanted to say that I too have the right to breathe and to cry out. But others wanted to stifle and silence my screams on my lips and my breath in my lungs. They had chosen winning weapons, and I was unable to 'laugh anymore.' "[3] Or again, in "A Poem for You" from the *Osyan* (Rebellion) collection, Farrokhzad writes:

> It was I who laughed at futile slurs
> the one that was branded by shame
> I shall be what I'm called to be, I said
> But oh, the misery that "woman" is my name.[4]

Propriety demands the omission of woman—her body covered, her portrait undrawn, her life story untold. Just as in the

Qur'an, no woman other than Mary, mother of Jesus, is referred to by name, traditional men would prefer not even to mention their women's names in front of strangers. A woman's proper name is improper in public. Disclosure of her identity is an abuse of privacy, while her minimal exposure is the accepted—in fact for long the ideal—norm.

The norms and values which regulate the extent and quality of woman's physical accessibility apply to her verbal expressivity as well. If, through her veiling, one channel for the transmission of messages is curtailed, through her silence and self-erasure in public the channel of verbal disclosure is also inhibited. It should not come as a surprise, then, that no veiled woman has ever published the details of her personal life, let alone a novel or an autobiography, whereas unveiled women have published a substantial number of both genres. In the resolutely nonsexual and impersonal writings of such women, the author remains almost inaccessible. The reader is kept at a strictly measured distance, learning very little of an intimate nature about the writer's personal life. For the most part, veiled women have not committed any kind of voluntary self-revelation in public. Even in interviews of female political figures of the Islamic Republic, women's traditional habit of self-effacement runs deep. Personal questions are generally evaded, and if answered at all, they are confined to male familial relationships, such as whose daughter, sister, or wife a person is.

A woman who prides herself on her inaccessibility, whose ideal state is cloistered, can hardly be interested in such an undertaking as revealing her private life. To borrow a metaphor used repeatedly, she is like a pearl in a shell. She has no interest in exposing herself, in opening up, in going public. She prefers to keep out of sight, concealed, covered.

Woman's textual self-representation cannot be divorced from her cultural representation. In a culture where walls and veils abound, where a woman is expected to cover her body as she

is presumed to conceal her voice, in a sexually segregated society where access to her world and words is rather limited—in short, in a society where the concept of honor is built around a woman's virginity, the token of her inaccessibility—autobiographies with their assertive self-displays and self-attention cannot easily flourish. The feminine ideal of silence and restraint, her physical anonymity in repetitive veils, and all in all her cloistered selfhood seem to be major obstacles to the full development of female public personal narratives.

Sexual segregation not only minimizes or circumvents the frequency of male-female interactions but also ritualizes their content. In other words, what can be revealed about a woman is carefully segregated from what must remain concealed. Historically, her personal life has been a privatized experience. She is the personal, the private. She is the secret. Accordingly, the term *mahram*, besides referring to one freed from male-female interactional constraints, also signifies a confidant. He is not only one who can see beyond the veil, but also one who can be trusted with secrets. By the same token, the verb *kashf kardan* can be used for both disclosing a secret (*kashf-e raz*) and unveiling a woman (*kashf-e hejab*).

Such a cultural scene does not seem to be a proper place for woman's autobiography, that most public unveiling of details. There are sorry consequences for the woman who opts for breaking the silence, for naming the formerly unnamed, for moving beyond the accepted paradigms of female self-representation—indeed, for subverting the system by committing herself to the autobiographic project and dissociating herself from the figure of the ideally mute, self-abnegating, self-denying woman. In *Savushun*, for example, the first novel written by a woman in Iran and published in 1969, Miss Fotuhi, the antiheroine, transgresses conventional female life-scripts.[5] Wanting voice and visibility, she unveils herself publicly before

the compulsory unveiling act of 1936 and writes her life story. This desire to give voice to her body and to give body to her voice ultimately leads to her madness. Her nakedness, in both a literal and a literary sense—her appropriation of her body and of her pen—becomes her crime. She is thrown into a mental asylum where both her body and her pen are kept under seal, censored and suppressed. Self-representation turns into self-destruction, gestation into decay, song into silence.

Having trespassed across the sexual and textual boundaries, Miss Fotuhi has been violently silenced, concealed, confined. However, even trapped in a mental institution, she refuses to vanish into nothingness. She scribbles her untold tale and, ironically, gives her life-as-script to Zari, the conventional heroine who is her frequent visitor at the asylum. Zari is to place it in a safe-deposit box, rented by her brother. And so, even if fully written, her self-as-text, like herself, will leave no trace behind. It will remain hidden in a locked box, its key in the hands of a man.

No one knows how many such women's autobiographies exist, securely buried: body and text in boxes, left to oblivion in silence and isolation. No one knows how many more women silently witnessed their literary creativity die over and over again owing to unfavorable conditions. But women were ultimately irrepressible. They refused to surrender to anonymity and found other channels for personal expression. They interwove the fabric of their lives in the warp and woof of tapestry, stitchery, and embroidery. They were perpetual story-tellers, who imbued their tales, their lullabies, their songs, and their games with their personal lives. In all likelihood, these unwritten, forgotten, or disguised life-narratives, like their authors, will rarely be unearthed and revived. They will remain unacknowledged identities, dead presences, veiled mysteries.

Only a few autobiographies, all by nonliterary figures, for

one reason or another escaped anonymity and saw publication. These are the rare exceptions, which come as a great surprise after a tradition of a thousand years. It is difficult, in talking about women's autobiographies in Iran, not to start with Tahereh (1814–1852), who never wrote an autobiography. She is, however, the first woman who publicly discarded her veil, in 1848. Through her unveiling and her public preaching, she exposed her body and her voice and committed the first public autobiographical act on record in contemporary Iran. She also appropriated the language of the pulpit, that traditional male medium. She became her own interpreter: a body with a voice, a voice with a body—a body which refused to slip away in silence, a voice which defined the speaking subject as female and authorized her public life.

Unveiling her body, as she unveiled her voice, Tahereh used her self as text and context, as a medium through which to break out of the silence that concealed her culturally. Hers was an assertion of a woman's individuality and distinctiveness in an age that demanded nothing less than conformity and anonymity from its women. She wanted her body seen, her voice heard, her individuality asserted. She wanted to lift the veil of secrecy.

But her voice, her sermons, her unveiled body all became signs of contamination; tokens of an unleashed sexuality that was deemed dangerous to the social order; a physical, textual, and religious transgression that did not attend to the conventional shape of female selfhood. Speaking directly, autobiographically, she, too, could not avoid censure. She was strangled to death at the age of thirty-six for her open advocacy of a new religious faith, Babism. She is the first recorded woman in premodern Iran to have been executed by a governmental decree.

Despite being maligned, labeled, and harassed, many other women writers unveiled themselves and created a sense of an

"unveiled" self in their works. They wrote about hitherto private ideas and feelings, autobiographical facts, and personal experiences. They refused to subordinate the authorial voice to traditional stereotypical characterization, nor did they maintain the socially prescribed psychological distance. They led the reader beyond walls and veils, to the domain of the private. In their works feelings are not rationalized, passions are not diluted, emotions are not flattened, details are not evaded. These authors made a deliberate effort, in fact, to amalgamate the personal and the collective, the private and the public.

Refusing conventionally stylized modes of expression, avoiding lofty, impersonal descriptions, questioning traditional values, and redefining moral and social properties, these women created a sense of self divorced from the conventional definition of womanhood—a naked self, as it were—that is all the more vulnerable in a closed-in society where highly censored communication is the order of the day, where in the words of the novelist Shahrnush Parsipur (b. 1946), "people whisper even behind tall walls."[6] With a distinctly female voice, these writers challenged and rejected the dominant value system of their culture. Increasingly interested in the individualized, unrestrained portrayal of relationships between men and women, they often trespassed the verbal territory allotted to women even within the confines of the private. By textualizing the range and variety of female experiences, by saying "I" in a written and potentially public text, by showing a reverence for and fascination with the individual, these women lifted the veil of secrecy to show the many faces of reality underneath. They are the pioneers of an autobiographical consciousness, even though none of them to this day has published her autobiography per se.

In 1982 the novelist Simin Daneshvar (b. 1921) explained why there are such self-imposed limitations on the direct revelation of the self among Iranian writers:

> Generally speaking, the Eastern artist is very humble and has little self-confidence . . . Also, autobiographical writing cannot flourish in a conservative and possibly hypocritical society . . . Our society fears sincerity and honesty. Recently, I read Simone de Beauvoir's autobiography. What a happy and cheerful life she had. She studied on time. She gratified her sexual needs on time. But then what about me—Simin Daneshvar—who had to witness thousands of unpleasant events. First, in a corner of Shiraz, and later behind a cemetery in Teheran, I had to struggle for basic human needs. What is there to write about other than pain and sorrow?[7]

Granted the part played by humility, self-censorship, discretion, and unfavorable living conditions, the fact remains that whereas male writers have produced a handful of life narratives, no woman literary figure has ever published an autobiography. In fact, even the most autobiographical of these writers have shown a pronounced aversion to giving even the scantest biographical data on themselves.

Forugh Farrokhzad, for instance, who systematically integrated a female self—her own—in her five collections of poetry, otherwise avoided talking about her personal life. When Iraj Gorgin asked her to talk about herself, she dismissed the question, saying: "By God, discussing this seems to me a rather boring and useless task. Well, clearly, anyone born has a birthday, is native to a certain city or a certain village, has studied in a certain school, and a handful of conventional and typical events have occurred in her life, such as falling in a pool during childhood, cheating in school, falling in love during adolescence, getting married, or some such things."[8]

Mahshid Amirshahi (b. 1937), whose adolescence is the stuff of most, if not all, of her short stories and whose personal experience of the Islamic Revolution is the content of her recent novel-qua-political memoir, shows no less objection to talking

directly about herself. In an introduction to a selection of her short stories published in 1972, republished verbatim fifteen years later as the introduction to her first novel, she writes: "I don't believe my birthday, my birth certificate's number and place of issuance, my mother's name, and my father's occupation are interesting to anyone except officials of the office of registry. So would you kindly relieve me of the agony of writing these details as you will rid the readers of reading them. . . . To insist on knowing these details shows a lack of sensitivity."[9]

Perhaps both these writers and many others like them were reacting, to a certain extent, to the obsessively sensationalistic interest of the literati in their lives, especially in their relationships with men. This interest replaced the serious attention that their works deserved, and all too often it led to the denunciation of them as decadent or excessively personal. Mary Ellmann does not exaggerate when she observes that "books by women are treated as if they themselves were women, and criticism embarks, at its happiest, upon an intellectual measuring of busts and hips."[10]

The works of many women have also been branded as merely autobiographical and devalued in the process for the primacy given to feelings and to an introspective, intimate kind of writing. This labeling has always carried negative connotations, designed to reinforce the notion that these women do not and cannot transcend the limits of the private. Indeed, the works of many women have been slighted and excluded from literary histories and anthologies because the value structure of an almost entirely male literary tradition has insisted that only certain kinds of experience are worthy of serious consideration. Women's personal lives have consistently lacked a part in this system. As a result, both Farrokhzad and Amirshahi, after refusing to talk about themselves, proceeded immediately to draw attention to the inherent value of their works.

Of the few nonliterary women who have given ostensibly factual accounts of their lives, claiming to have written about historical rather than fictional material or poetic self-invention, all were famous, if not notorious, prior to their embarking upon their autobiographic projects. For one reason or another, their lives had already been uncovered, exposed, publicly talked about.

The emergence of these autobiographies can be traced to no earlier than the mid-twentieth century when Banu Mahvash, a singer-dancer, and Malekeh E'tezadi, a political activist, published their highly unconventional life stories. Although *The Memoirs of Taj os-Saltaneh* was written in 1924 by Naser ed-Din Shah's daughter, it was not published until six decades later, in 1982.

However limited in number, women's autobiographies constitute a highly heterogeneous body of works. From the political activist Ashraf Dehqani to Princess Ashraf Pahlavi, from the Marxist revolutionary Marziyeh Osku'i to Sorayya Bakhtiar, Mohammad Reza Shah Pahlavi's second wife, their works include different political allegiances—from royalist to communist, from rightist to leftist, from reformist to revolutionary. Within the broad framework of religious ideology, they are no less divergent. At one extreme are the women fully committed to secularization. At another extreme, the traditionalist Parvin Nowbakht sees salvation only in the reinstitution of Islamic values and an Islamic world view. The autobiographers are as diverse in their backgrounds as in their perspectives. From Farah Pahlavi to Forugh Shahab to Marziyeh Osku'i, they represent widely different social and economic statuses, from the very rich to the very poor.

Underneath these dissimilarities, however, lurk fascinating similarities. All of the life scripts, for instance, have a sense of self deeply rooted in the public domain, representing what Bakhtin calls rhetorical autobiography.[11] They are devoted

mainly to the defense of a political career, a religious cause, a notorious life. Resembling beefed-up curriculum vitae, most, if not all, of them are purposive, characterized by one major preoccupation or another. Although their time frame is often stretched by means of free association, flash backs, and flash forwards to cover a whole life, most of the works have the manifest intent of recording the unfolding of a specific event. The very act of writing these personal narratives is presented at times as a sort of duty, a mission sometimes divinely planned, sometimes politically or socially mandated. In one passage Nowbakht explains why she finally decided to write *Marivan Lake, at Six O'clock:* "Why do I write? Why do I write these memoirs? Why do I pollute the dearest memories of my life's most precious moments with the mediocrity of words? Why should these memories reach the ears of others? . . . Well, I only write because you ordered me to."[12]

Of the concerns that recur frequently in these works, the most common is the desire to destroy a "false" image. Their primary purpose proves time and again to be the rectification of misperceptions regarding the author, setting the record straight once and for all. Through control of what the reader should know about the author, they present and cultivate a more desired public image. As a cultural effort at self-vindication, a theatrical act with the ideal self being the mask, such autobiographies seem to be addressed to an invisible judge and jury. In the introduction to *Faces in a Mirror,* Ashraf Pahlavi writes:

> Two decades ago French journalists named me "La Panthere Noire" ("The Black Panther"), and I must admit that I rather like that name, and that, in some respects, it suits me. Like the panther, my nature is turbulent, rebellious, self-confident. Often, it is only through strenuous effort that I maintain my reserve and my composure in public. But in truth, I sometimes wish I were armed with the panther's claws so that I might attack the enemies of my country. I know that these enemies—and particularly in

the light of recent events—have characterized me as ruthless and unforgiving; almost a reincarnation of the devil himself. My detractors have accused me of being a smuggler, a spy, a Mafia associate (once even a drug dealer), and an agent of all intelligence and counterintelligence agencies in the world.

It is in part such allegations that have also led me to write this book—not as a way of defending myself, but as a way of considering these charges candidly and truthfully, and as a way of setting out the political events in my country, as well as the events of my personal life.[13]

Although these narratives purport to be vehicles to allow the authors to speak for themselves, they actually incorporate multiple voices, especially that of a biographer. Because their approach to the author's own life is not particularized, the distinction between biography and autobiography is at times blurred; in fact, some of these works were allegedly written by ghost writers. Just as biography is somehow restricted by the writer's lack of access to the private life of the subject, so, too, this kind of book keeps its readers at a distance. Its preoccupation with the public image forms a barrier as solid and forbidding as the walls and veils around the private self.

Also typical of all these works is a firm belief in the author's privileged knowledge of herself, of her "real," "unified" self. Most of them strive to reveal their author's true identity buried beneath thick layers of misconception and false accusation. They show a totally different private self beneath the "social" one. It is comfortably taken for granted that the core and the shell, the inner and the outer, the essence and the appearance, do not and need not correspond.

Self-analysis, regarded as essential in some autobiographies, is not the favored objective of most of these works. The intensely self-reflexive *The Memoirs of Taj os-Saltaneh* is an exception. It is a strikingly original venture in self-revelation that goes far beyond the conventional. Defending her self-scrutiny, the author

writes: "Ah! My dear teacher and cousin! Do you believe that I should occupy myself with any other kind of history, while my own past and present is a sad and amazing history? Is reviewing one's own history not the best preoccupation in the world?"[14]

And yet for Taj os-Saltaneh, as for almost all other autobiographers, the self cannot be represented except in its relations with men. The unfolding of the narrator's consciousness takes place through relationships with a chosen masculine other. Marziyeh Osku'i discovers and reveals herself in relation to the masses, the faceless crowd, personified as a lover.[15] Parvin Nowbakht, with no less intensity, focuses on a spiritual community at the center of which is her martyred husband.[16] In spite of a distinctive personality present throughout her *Faces in a Mirror,* Ashraf Pahlavi seems ceaselessly to need a man through whom to define herself. Paradoxically, this man is her twin brother, Mohammad Reza Shah Pahlavi, the same brother who unhesitatingly offered her as a sacrificial lamb on the altar of revolutionary fervor by denouncing her and exiling her first in 1951 and again in 1978. Nonetheless, the author is much more concerned with her brother's accomplishments than with her own personal and controversial life story. She seems to plead the case of her brother rather than stressing her own achievements or failures.

The age-old, stereotyped comparison of a woman's beauty to the moon is more than a merely physical analogy for these books. Emotionally, too, the ideal woman, like the moon, revolves around a sun in her life and takes her definition from him. The image of the ideal woman—moon-faced, emotionally moonlike, distant, virginal, silent, living in a world of muted distinctiveness and desire—haunted these autobiographers, as it did the society at large. The emergence of a new and different female character, in literature and in life, exposed the contradictory aspirations of even the secular, modernized sector of soci-

ety. To Muslim fundamentalists, the rupture of traditional and Islamic values was most visible and least tolerable in the area of women's emancipation. But neither could the modernized, educated elite, who claimed to champion women's rights, reconcile themselves to the changes affecting their status. They were both fascinated and terrorized by this new woman, who certainly did not fit the tight mold of ideal femininity.

Modern Persian literature is thus filled not only with the painful silences of those women who were denied conditions conducive to the mastery of their creative potentials, but also with the painful struggles of those few who refused to be crucified on the cross of "ideal femininity," who declined to remain selfless to the point of extinction from the literary arena, who demanded formal and authorized access to public discourse, and who rebelled against the hegemonic figure of female selfhood. Their autobiographical works are the glorious chronicle of a voice regained, while their lives are testimony to much suffering, conflict, and sorrow. It is within this cultural context that the poet Tahereh Saffarzadeh (b. 1936), donning the veil, took a revitalized interest in Islam and left her earlier personal poetry for an impersonal religio-political poetry, in which spontaneity is leashed, diversity eliminated, individuality caged. The novelist Goli Taraghi (b. 1939) created a masculine fictive world in which feminine voices, concerns, and points of view, if presented at all, are fully subordinated to a universe crowded and governed by men. Shahrnush Parsipur suffered total neglect. Taj os-Saltaneh, holding on to her voice and vision, tried to kill herself thrice; Forough Farrokhzad and Mahshid Amirshahi each attempted suicide once. Thus, to write autobiographically with the individual and individualized imprint of a female voice—this renegotiation of old sanctions and sanctuaries, this public unveiling of body and pen—has proved to be a costly enterprise for the Iranian woman.

· T W O ·

A Different Voice: Taj os-Saltaneh

AFSANEH NAJMABADI

Khaterat-e Taj os-Saltaneh (The Memoirs of Taj os-Saltaneh) have a special place in the study of women's lives in Iran at the turn of the twentieth century.[1] Woman's social situation, as well as her individual expectations, had been a source of uncertainty and conflict, pointing to the desirability and possibility of change, from the middle of the nineteenth century, a century marked by deep challenges and changes. As in the rest of the Middle East, the changing climate of political ideas and social concerns associated with this period in Iran included, for the first time, the problem of how the female half of the population should figure in the type of new society that was being projected.

But these changes, for the most part, were molded not by women but by men, the men of pen, of religion, and of state. The latter had defined, and redefined, the "woman question," since mid-nineteenth century. The first novels and plays criticizing the existing position of women and projecting new images were written by male novelists and playwrights; the first political essays, *The Emancipation of Women* (1899) followed by *The New Woman* (1901), were authored by a man, the Egyptian writer Qasim Amin. The traditional woman was to become the new modern woman, but as created by the new Middle Eastern man.

I do not mean to imply that Middle Eastern women have been mere objects of change, or should be viewed as victims of modernism. By the turn of the century, women were already writing about their own expectations, hopes, and images for change. But in the earlier formative period, much of the ideas about change were shaped and expressed through new literary forms such as plays, novels, and political essays—all of which acquired a powerful place in the shaping of public opinion because of the introduction of printing into Middle Eastern literature. Unlike the traditional oral literary forms, this new arena remained an exclusively male prerogative for several decades.

Nor do I mean to impart omnipotence to the modern Middle Eastern man. The experience of modernity for Middle Eastern societies has been powerfully shaped not only by internally generated factors but also by the encounter with Europe, an encounter whose impact was not limited to military might, economic penetration, and political dominance. Along with European matches, textiles, and guns came the ideas of the French Revolution, the universalist and secularist appeals of the Enlightenment, and the assaults of modernity, all of which made a deep impression on a generation of Middle Easterners, overwhelmingly men, who went to Europe as students, translators, or diplomats. The emerging political ideas and ideologies of the modern men and the modern states in the Middle East were born within a highly contested terrain defined not only in relation to the traditional discourses of religious and political order but also in interaction with and reaction to Europe. In that context, as Deniz Kandiyoti has argued for the Tanzimat reform period of the Ottoman Empire, " 'the woman question' . . . served as a vocabulary to debate questions of cultural and national integrity, notions of order and disorder, and finally conceptions of the indigenous relative to the foreign."[2]

In Iran, the earliest piece of political writing with any extensive discussion of the "woman question" as such appears to be *Sad khetabeh* (A Hundred Sermons) by Mirza Aqa Khan Kermani (1853–1896).[3] Written in the form of addresses by an imaginary Prince Kamal od-Doleh of India to a Prince Jalal od-Doleh of Persia, *Sad khetabeh* expresses Kermani's concerns with Iran's "social ills." In several of these sermons, Kermani addresses the deplorable situation of women in Iran. Much of his argument is directed against three institutions: female seclusion and the veil, polygamy, and temporary marriage (*mut'a*). He contrasts the secluded urban women of Iran both to their tribal sisters, of whom he speaks with great admiration, and to European women. He holds seclusion and the veil responsible for women's illiteracy and ignorance about the world. The veiled, secluded woman, he argues, is deprived of her full humanity, of enjoyment of life, and of any avenue to render herself socially useful. He maintains that men would behave more nobly if they could enjoy female company. Without any opportunity to socialize with women, men turn to homosexuality and to slaves or young boys for satisfaction of their sexual desires. Moreover, he contends that arranged marriages, between partners who have not even seen each other until the night of consummation, are not based on mutual liking and go sour from the beginning, while in Europe prior socializing strengthens the bond of marriage. Kermani also argues against polygamy and temporary marriages, holding them responsible for many social ills, including the lower rate of population growth among Muslims in comparison to peoples of China and Europe, the high incidence of child murder (by stepmothers who are jealous of their husband's attention to another wife and her children), and the unhappy marriages that turn women to trickery and superstitious practices in order to win back their husband's heart.

The situation of women also received notice in newspapers

of this early period.[4] Women are discussed there primarily as wives and mothers, that is, in terms of their impact on the political and social behavior of their husbands and their children. References to women as citizens of the new social order are almost nonexistent. The improvements called for in the lot of women concern removal of the veil (*hejab*), opposition to polygamy, and advocacy of women's education, all of which reforms are supported by the argument that they would make women better companions for their husbands, since men with supportive wives make for more responsible and socially conscious citizens. Reforms for women would also produce better, more educated mothers of the future generation. These arguments are similar to early European arguments for reforming the social situation of women.

By the end of the nineteenth century, there appeared the first major "protest" essay written by a woman. *Ma'ayeb or-rejal* (Vices of Men) was written by Bibi Khanum around 1894–1895, in response to an essay written around 1891 by an anonymous male author, titled *Ta'dib-e zanan* or *Ta'dib on-nesvan* (How to Chastise Women).[5] *Ma'ayeb or-rejal* includes one of the earliest references by an Iranian woman to the situation of women in Europe. Bibi Khanum finds Iranian men's treatment of their wives wanting when compared to their European counterparts, and she laments Iranian women's seclusion at home, which binds them to a life of performing household chores, while European women have a public life and mingle with strange men.

It is not known how Bibi Khanum came to form her ideas about the lives of European women. For male reformers of the nineteenth century, a great influence on their changing ideas about women was their actual experience of living in European cities as students, diplomats, visitors, and, later, exiles. But these early reformers generally did not take with them to Europe

their wives or sisters. A few wives may have traveled with their husbands for brief periods to certain cities, such as St. Petersburg. The first known cases of female students in Europe did not occur until the 1920s. In other words, women did not share the same experiential shock as men. A possible source of these new images for women, aside from what men wrote about European women in travelogues, novels, plays, and political essays, could have been the European wives of missionaries, diplomats, and travelers to Iran, with their different life styles and patterns of male-female association.[6]

Some of the first reflections of women's new images of themselves appear in letters written by women to journals that were published during the Constitutional period, from the early years of the twentieth century through the 1920s.[7] The first women's journal, *Danesh* (Knowledge), appeared in 1910.[8] Excluding poetry, the first extensive piece of new writing by women was Taj os-Saltaneh's memoirs, written sometime around 1914, when she was about thirty years old.[9] Given the autobiographical nature of these memoirs, they constitute an invaluable source for learning about how a woman's ideas were formed, how these ideas differed from those of her male contemporaries, and what were the inherent tensions of breaking through social and moral boundaries.

This autobiography is rare within its type because it projects itself and its worth as autobiography, not as social history or social commentary.[10] In other words, it is one of the few writings in Persian in which the author, male or female, attributes a value to the discussion of her own life as such. In response to a teacher's suggestion that she should read history to avoid depressive self-speculation, Taj os-Saltaneh argues: "Ah! My dear teacher and cousin! Do you imagine that I should busy myself with the history of others, while my own past and my present situation are themselves a bewildering and disagreeable

history? Is it not the best preoccupation in the world to review one's personal history?" (p. 5). The teacher remains skeptical: "Ah! A history centered around one's person, in all its good and bad consequences of that experience! No! I do not consider that history" (p. 5). But Taj os-Saltaneh insists: "My history is so important and so full of difficult events that if, over the course of a full year, I were to tell you of all the hours of my life, it would still not be finished. And it is sometimes so sad, at other times so jolly, that it would surprise the listener" (p. 6).

Unlike most earlier women's writings, which were essays or short letters, Taj os-Saltaneh's memoirs are book-length. They are also in prose, not poetry. In their style of writing, they aspire to emulate the European novel: "I very much wish I were a capable writer, like Victor Hugo or Monsieur Rousseau, and could write this history in a pleasant and very readable prose. But, alas, I can only write it in very simple and humble prose" (p. 20). Like a novelist, Taj os-Saltaneh pays close attention to the description of character, as well as of natural and social settings. She persistently provides rationalistic and psychological explanations for feelings and tensions, including her own contradictory ones.

Several influences played a part in the formation of Taj os-Saltaneh's ideas. First and foremost was the general climate of ideas during her formative years, as she received those ideas through her teachers, tutors, and, later, admirers and perhaps lovers. Taj os-Saltaneh was born on February 14, 1883, to Naser ed-Din Shah, the Qajar king, and one of his many wives, Turan os-Saltaneh. At an early age, she attended the court *maktab* (traditional school). She was married on December 9, 1893, some two months before she turned ten, although the marriage was not consummated until she went to her husband's house in May of 1897 at the age of thirteen. Once married, as was the custom at the time, she stopped attending school. Some years

after joining her husband, disappointed and disillusioned by a troubled married life, she threw herself into a period of intense studies, tutored by "a close relative." She neither reveals the name of this person nor explains exactly when the tutoring occurred and how long it lasted. But the tutoring must have started sometime around the age of eighteen in 1901, because the memoirs describe her early married life and her four fullterm pregnancies and one abortion before reaching this period.[11]

There is no doubt that the time of intense study in the early 1900s was a turning point in Taj os-Saltaneh's life. This comes through strongly both in the changes that she describes in herself and in the sharp conflict that emerges between her earlier convictions and her later ambivalence. She frequently describes her early self as a spoiled and frivolous princess. Her later voice, bitter and regretful at times, is that of a self-reflective, torn individual who is seeking to locate her personal disappointments in life within the larger human and social conditions of her time and to find a way out of them.[12]

Another source of Taj os-Saltaneh's changing ideas was her vast reading from an early age. As she says several times throughout the memoirs, she knew French as well as Persian. As soon as she stopped attending school, she spent her days reading classical "poetry of Hafez and Sa'di, quitting childish games somewhat, and reading nice books and sweet novels" (p. 33). In addition to reading novels, she attended the plays staged every evening in her husband's family's house (p. 35). During this period European plays in translation, or Persian adaptations of those plays, were very popular, and they were regularly staged at the royal court and among aristocratic families.[13] In addition to European literature, she seems to have been familiar with European history and possibly with ancient Greek and Roman history. She makes surprisingly accurate references to

the political debates of late nineteenth-century France (pp. 10–11).[14] Like some other Iranian women of this period, she was aware of the suffragette movements in Europe and America, as well as of the reforms adopted for women in the Ottoman Empire and in Egypt.[15]

Last but not least, her own life experiences had an enormous impact on her break from tradition. Not only had her new ideas about life and society, as well as about women's potential in contrast to their existing state, created an enormous urge to rebel and free herself from the confines of the traditional female quarters, the *andarun* life, but her special social place as the daughter of a powerful shah paradoxically intensified the contradiction between her potential desires and her actual possibilities. As a shah's daughter, she was somewhat protected from the popular persecution and vilification experienced by many pioneering women of the period. She could have young male tutors; she could play music, paint, unveil herself, and speak her mind. Yet that same privileged status deprived her of the type of fulfilling avenues available to other Iranian women, such as founding schools, publishing women's journals, or becoming a doctor. Her life, by definition, was one of idleness. She speaks bitterly and critically about this idle *andarun* life. It is no wonder that, among the texts of this period, hers alone discusses at length the necessity and desirability of employment for all classes of women.

She had a broad knowledge of and well-formed opinions on many issues of her day. For instance, she was a strong supporter of the Constitutionalists, in which she differed from her royalist husband. She had definite ideas about how to develop the Iranian economy, and she held strong views about women. Some of the themes about women that she brings up are common to the literature of the period written by men. Among them are the desirable prospects of education for women and the harmful

effects of their confinement and the veil. The removal of the veil was often advocated in order to make female education possible. Occasionally unveiling was also advocated to facilitate a better marital choice. Female education itself was promoted on the basis of its positive impact on the role of women primarily as mothers and secondarily as companions to their progressive husbands. Taj os-Saltaneh echoes some of the same arguments:

> But these [her mother's good looks and religiosity] by themselves do not suffice for a person to be a good princess as well as a fine mother. There are certain qualities necessary for a mother which she did not have. I do not mean, God forbid, to condemn my respected, saintly mother. No! It was no fault of hers. Rather I should condemn the country's traditions and morals that have closed all the roads of progress and happiness to women and have kept these miserable creatures in the depths of ignorance. And all the moral defects and corruptions have been produced and spread throughout this country as a result of women's ignorance and lack of knowledge . . . All those who have been the source of great historic works were . . . brought up under the support and attention of knowledgeable mothers and progressive fathers . . . All real fighters and true independence-seekers and sincere supporters of liberty were born of mothers . . .
> Yes! It is a good mother who is a teacher of morality, it is a knowledgeable mother who has children to be proud of. And again it is because of mothers that today we are subject to this kind of misery and neglect, breaking down our independence . . . Patriotic feelings and noble earnest yearnings for progress have been purged from us since childhood; we have been taught nothing but eating, sleeping, and looking after our physical comforts. (pp. 7–8)

Similarly, she argues for marriage based on choice as opposed to arranged marriage, and she disapproves marriage at an early age (pp. 26–28). Yet compared to writings on similar topics of

her male contemporaries, Taj os-Saltaneh's arguments locate the woman herself, rather than the children or the husband, at the center of the argument. She argues for female education not simply to make women better mothers but also to help them gain employment and end their "empty, futile lives." She wants women unveiled, educated, and employed so that they can become full participants in the social and political life of the country. When discussing her ideas on social reform, she talks not about what statesmen should do but about what she herself should do:

> My teacher! If women in this country were free as in other countries, if they had attained their rights and could participate in political and national affairs and move ahead, I would most certainly not see my path to advancement in becoming a minister and trampling upon people's rights and embezzling the property of Muslims and selling off my beloved country. Rather, I would choose a correct path, with a firm plan for my progress. I would never buy a house and a park, furniture, carriages, and an automobile with people's money; rather I would acquire them through work and service. (p. 98)

She speaks in her bitterest terms about the life of Iranian women, particularly in contrast to what she has learned about women in Europe and America:

> Alas! Iranian women are separated from the human species and count as animals . . . they live from dawn to dusk in a hopeless prison and pass their lives under severe distress and unpleasant misfortunes. And all this while they see from afar, they hear and read in newspapers, that women fighting for their rights in Europe defend themselves and demand their rights in such serious pursuit. They demand the right to vote, they demand to be elected to the parliament and participate in political and national affairs, and they have succeeded in these struggles. In America they have

gained full rights and are busily engaged in work. The same in London and in Paris. (p. 99)

Despite many such instances of despair, she makes positive projections about what can be done to change this miserable situation. When "during the period of Lesser Autocracy," from June 1908 to May 1909, she receives a letter of inquiry from Ba'e-anov, an Armenian Constitutionalist from Caucasia, concerning the meaning of constitutionalism and the road to progress, she lists the duties of Iranian women in these terms: "To gain their rights like European women; to educate their children; to help men as European women do; to be chaste, pure, and patriotic; to serve humanity; to reject laziness and staying at home; and to take off their veil" (p. 100). Ba'e-anov asks for clarification: "What connection is there between progress of the country and the unveiling of women?" (p. 100). In reply, Taj os-Saltaneh points to the veil as an impediment to female education and employment for both lower- and upper-class women. She also argues that without the veil, marriage could be based on choice. This would greatly increase the spiritual union of the family, and once women were economically active citizens and supportive companions, people could put their minds and energies into social reform and development.

Her discussion of the evils of married life in urban Iran is coupled with a highly romanticized view of male-female relationships in rural Iran. This became a common feature of the views of urban writers on rural peace and spirituality. Her description of the idle life of the upper-class woman, with its boredom, frustration, and outbursts, sounds highly autobiographical.

In her twenties, she was surrounded by a group of young male admirers, whom she described bitterly as "flatterers" and whom she held responsible for the break-up of her marriage. By

the time she wrote her memoirs, she had clearly become concerned about her public image. She feared that people would attribute her ideas to personal motivation and the desire "to get out" of the confines of her house and might consider her ideas illegitimate and corruptive of other women.

Conspicuously absent from her views is any discussion of polygamy, a common theme of social criticism in this period. This can be attributed to two factors. First, because of the early end to her own married life, she never had the experience of a rival co-wife to arouse her concern with the issue. It is highly unlikely that, if she had had such an experience, she would have failed to express her outrage at it. She makes sharp observations about the harem life of her father, without ever mentioning the polygamous situation as a cause of the troubles. Her own advocacy of marriage based on love assumes monogamy.

The other reason for her failure to criticize the institution of polygamy may be her fondness for her father, making her unwilling to criticize his main mode of relating to women. From the memoirs, it is clear that she had great admiration and love for her father and was deeply affected by his assassination in 1896 when she was thirteen, while carrying ambivalent feelings toward her mother. Repeatedly, a deep anger comes out toward her mother, who is portrayed as uneducated and thus incompetent. Following the custom of the day, Taj os-Saltaneh was entrusted to wet-nurses and nannies, a circumstance she describes as depriving her of early bonding with her mother. With the subsequent birth of her brother, her mother is said to have given him greater love and attention. Here is another area where Taj os-Saltaneh's text differs from other texts of the period, in that she devotes so much attention to discussing and almost psychoanalyzing early human bonding development. She argues strongly against wet-nursing, emphasizing the importance of early mother-child attachment through breast-feeding. She re-

grets the formality of her relationship with her mother, which resulted from their separation except during arranged visits. She attributes to this early period her own deep and lasting attachment to her nanny. She argues that if she had brought up her own children instead of entrusting their upbringing to wet-nurses and nannies, as was the custom in aristocratic families, she would have been so attached to them that no matter how bad her marriage, she would have stuck it out for their sake.

Taj os-Saltaneh's memoirs are striking for their deep-seated tensions and intense contradictions, apparent on virtually every page. Such tensions and contradictions drove Taj os-Saltaneh to attempt suicide three times before she wrote the text. They produced a torn and depressed woman, estranged from her children and viewed as morally corrupt by her contemporaries.[16] Because of the then-unacceptable way she chose to break out of the confines of her suffocating life, by entertaining young male admirers and perhaps lovers, she became an outcast. She was one of the first Iranian women in the modern period to experience the tremendous social and psychological pressures of crossing over the boundaries of social morality.

This experience proved treacherous and hazardous for women. As new ideas about change and progress seeped into Iranian society, men who considered themselves and were by others considered progressive could no longer accept traditional male-female relationships. An illiterate, veiled woman was no longer a fit companion for a progressive man. Yet to become the female counterpart of a progressive man was a dubious venture. To become a progressive female, as Taj os-Saltaneh was persuaded to do by her tutor, awaked in a woman the desire to break out of her social confines, to drop her veil, to socialize with men, and to become literate and opinionated. But at every step this breaking-out had to take place within a new set of socially controlled boundaries, determined not by the woman

herself but by the very same progressive men. For example, after arguing at length against the veil, for freer male-female interaction, against arranged marriage, and for marriage based on mutual love and acquaintance of the partners, Kermani concluded that things should not be allowed to go to the extremes that had occurred in Europe, where women were given so much choice and freedom that even if a man found his woman in bed with another man, he would not dare to be disrespectful to her.[17]

Women in Iran were thus faced with a contradictory project: to break out of one set of boundaries while happily accepting another externally determined set. Most did. Those few who did not were turned into outcasts, unless they would become repentant and set an example. The voice of Taj os-Saltaneh as it comes through her memoirs is that of a regretful outcast, but not yet repentant. The conviction of her new ideas comes through again and again. Toward the end, she expresses regret, yet she nowhere repents her convictions as morally wrong. Her new ideas and her new life choices harmed her, she admits in bitter candor, but throughout the text her voice of rebellion and anger remains dominant.

The tension in her memoirs does not appear to have arisen from the conflict between traditionalism and modernity, from "the dichotomy between traditional Persian values and modern Western ones."[18] Despite regretful passages, Taj os-Saltaneh did not experience at the time a conflict of values, nor was she resentful toward Europe.[19] The conflict that comes out in her autobiography does not reside in the realm of ideas and values; rather it lies in the dichotomy between her new convictions about the desirability of a different mode of individual and social life for women and her inability, accentuated by her own social position as a princess, to find any meaningful avenue for achieving this vision. To escape this contradiction, she could

play piano and *tar* (an Iranian string instrument), busy herself with needlework, read novels, watch theater productions, paint, have a circle of lovers and other people to amuse herself, become depressed, and attempt suicide. Yet none of these activities gave meaning to her life. Her deep sense of the futility of her life led her to find one scapegoat after another, one rationale after another, to explain it. She looked forward to the day when she would see Iranian women emancipated from this type of life, all the while feeling that there was nothing she could do to bring that day any closer. She could only long for it, offering to sacrifice herself as a token of thanks should such a day ever arrive (p. 102).

· THREE ·

An Autobiographical Voice: Forugh Farrokhzad

MICHAEL CRAIG HILLMANN

The dearth of biographies of Iranian literary figures is startling, especially in light of the centrality of literary biography in those western literatures from which twentieth-century Iranian writers have drawn inspiration.[1] For example, despite continuing fascination on the part of Iranian readers with the life of Sadeq Hedayat (1903–1951), the most influential Persian prose writer since Sa'di (c.1215–c.1290), no biography of him exists forty years after his death.[2] The same is true of Nima Yushij (1895–1960), the most influential poetic voice in Iran since Hafez (c.1320–c.1390), despite the fact that hundreds of letters and other archival materials have become available in the three decades since his death. Neither are there biographies of the prominent modernist poets Ahmad Shamlu (b. 1925) and Mehdi Akhavan-e Sales (b. 1928), or any other living Iranian literary figure.

Responses to attempts in the 1980s at a biography of a major Iranian literary figure intimate the culture-specific significance of the issue of biography. The literary critic and novelist Reza Baraheni (b. 1935) reacted to a 1980 biographical sketch of himself by worrying that its review of political issues in his life might jeopardize his academic career, if not his political freedom.[3] A 1986 biographical sketch of the expatriate poet

Nader Naderpur (b. 1929) evoked puzzlement on the part of an Iranian reviewer, who confessed that he had not previously seen, and was unsure how to respond to, a candid and dispassionate sketch of an Iranian writer's career.[4] The poet reacted by passing along to the biographer a friend's advice to delete everything from the sketch except for the poet's dates of birth and current marriage.[5] The expatriate writer and filmmaker Ebrahim Golestan (b. 1922) took issue with almost all of the biographical data in a book-length study of his employee and mistress, the modernist poet Forugh Farrokhzad (1934/5–1967), expressing the view that only invasion of privacy or titillation of readers could be behind such biographical inquiry.[6] In any case, according to one Iranian reviewer, that study, *A Lonely Woman: Forugh Farrokhzad and Her Poetry* (1987), was "the first biography of an Iranian literary figure ever published."[7]

Numerous factors help explain why Iranian authors might not gravitate toward biographical research, why literary figures might not feel comfortable with biographical inquiry involving themselves, and why Iranian readers might not encourage the production of literary biographies. According to Baraheni, traditional, culture-specific attitudes of conservatism and circumspection have been chiefly responsible for the dearth of biographical writing in Persian.[8] In other words, specifically Iranian concerns about the reaction of family, friends, neighbors, and society at large play a not insignificant role in the attitude of writers when it comes to telling the story of a writer's life. But the fact that Baraheni himself keeps his own discussion general and unpointed suggests another factor behind the dearth of literary biography: the need to engage in self-censorship to avoid governmental censorship or worse. In the authoritarian, patriarchal Iranian environment, biographies other than the approved lives of kings, their representatives, and other establishment father

figures might not have a place. In addition, because detailed or in-depth biographies of literary figures have not been a traditional part of Persian literary expression, readers cannot be expected to seek out, encourage, or appreciate the literary form. This factor in turn may discourage writers from biographical writing.

Reasons for the lack of biographical writing appear to be more numerous in the case of literary women, because of a distinction between the terms mask and veil.[9] While masks apply to both men and women writers, veils (the *chador* coverings that Iranian Muslim women wear) are designed exclusively for women. An Iranian woman writer whose voice is veiled is either one whom society keeps from view or one who acquiesces in response to societal pressure. The traditionalist poet Parvin E'tesami (1907–1941) is the classic case of a woman writer raised and taught by her literary father and encouraged by her brother and her traditionalist literary acquaintances to remain hidden behind both domestic walls and a poetic persona unidentifiable as female. Fereshteh Davaran notes the impersonality of E'tesami's "aloof" verse, which exhibits no reflection of the great social changes of her age, no references to romantic love, and no traces of womanhood or signs of the poet's gender. According to Davaran, E'tesami, who "never considered . . . possessive, paternal behavior as a violation of her personal rights," is consequently "the ideal female poet of the patriarchy . . . great praise of her poetry is not for what she 'says' in her poems, but for what she 'doesn't say.' "[10]

The poet Tahereh Saffarzadeh (b. 1937) is an example of the other sort of veiling, that of a woman literary artist who herself gradually acquiesces in the face of societal pressure or chooses to don a literary *chador*. After a failed marriage and graduation from Pahlavi University in Shiraz, Saffarzadeh traveled to the United States in 1969 to participate in the International Writing

Program of the University of Iowa, where she published a volume of verse that year in English (her first volume of Persian verse had appeared in Iran in 1962). In the early 1970s, she was something of a liberated woman and perhaps the most westernized poet of her generation. She produced two further volumes of verse in Persian before 1978, by which time she had begun advocating an Islamic basis to Iranian society and opting personally for a traditional female posture in dealing with people. Subsequently, she spoke and wrote in support of the Islamic Republic of Iran, was an unsuccessful candidate for Parliament in 1980, and was an admirer of Ruhollah Khomayni. By the late 1980s, remarried, she was living quietly in Shiraz.[11]

In contrast to veiling, an Iranian writer whose voice is masked does not hide his or her gender but freely chooses to keep the private, personal face from view or to project a public literary image different from that private face. For example, when asked his reaction to Jalal Al-e Ahmad's autobiographical essay *A Stone on a Grave* (1981), the prominent dramatist and short-story writer Gholamhosayn Sa'edi (1935/6–1985) confessed embarrassment that in the book his friend had candidly discussed fatherlessness, sterility, and sperm count. In the words of Sa'edi, who was a psychiatrist by training, real men like the poet Ahmad Shamlu do not talk about those things in print.[12]

That Sa'edi objects to writing which ignores conventional social decorum or literary mores and taboos does not imply that Iranian writers who have lived against the grain or apart from the mainstream of twentieth-century life are necessarily literarily candid or unmasked. For example, although Nima Yushij and Sadeq Hedayat refused to lead conventional lives on and off their pages, they are not functionally autobiographical in their work. In the case of Iran's first modernist poet, Nima Yushij, the persona of the sensitive Mazandarani rustic which he developed as a mask in his verse from *Afsaneh* (The Legend, 1921)

onward has little in common with the urbane, sensitive intellectual whose classical French education began in his preteen years at Tehran's Saint Louis Academy, or with the man who posed nattily attired for photographs on annual hunts near his "beloved" Yush, or with the man who, from the early 1930s, led an opium-clouded and vodka-soaked literary life in Tehran surrounded by people who paid his bills and doted on him.[13] As for Hedayat, this brilliant, sensitive writer almost impenetrably masks his personal desires and fears, even if there are grounds to associate him psychologically and philosophically with the protagonists of "Seh qatreh khun" (Three Drops of Blood), "Zendeh beh-gur" (Buried Alive), "'Arusak-e posht-e pardeh" (The Mannequin behind the Curtain), and other short stories, especially with the protagonist of his masterwork, *The Blind Owl*.[14] In that enigmatic novella, the influence of Rilke's *The Notebooks of Malte Laurids Brigge* is particularly intriguing because Rilke's work itself treats of its speaker's self and his masks and is a narrative reflection on getting behind masks.[15]

Hedayat and Yushij, at least in their literary works, were unwilling to reveal or admit what lay behind their masks and usually employed them to hide rather than to project truth. They also perhaps eventually identified with their masks, thus further submerging the potentially autobiographical personae. This kind of hiding and identification is common. Hafez, after all, does the same thing, as do most of the rest of humanity, at least socially. In addition, no criticism is implied in describing a writer's personae as masks over true visages. The point is simply that such masking is not conducive to literary autobiography.

As an example of an Iranian woman writer masking herself in her works, Goli Taraghi (b. 1939) deliberately utilizes multiple masks when she writes. In her novel *Khab-e zemestani* (Winter Sleep/Hibernation, 1973), she characterizes her own feelings

about life in Tehran during the later Pahlavi years and about life in general through sketches of a group of older Iranian men who are wholly unlike her in educational background, interests, and socioeconomic status.[16] Taraghi refers to her story "Bozorg-banu-ye ruh-e man" (The Great Lady of My Soul, 1979) as "a memento of a trip to Kashan with Sohrab Sepehri." Although the story portrays an ill poet friend who is recognizable as the prominent poet and painter Sepehri (1928–1980), the narrator-protagonist is a middle-aged man whose circumstances are far removed from Taraghi's.[17] As for her unfinished narrative *Adatha-ye gharib-e aqa-ye Alef dar ghorbat* (The Bizarre Comportment of Mr. Alef in Exile), the author insists that she is describing therein her own difficult time dealing with self-exile.[18] But the story is about what happens to a middle-aged, male ex-teacher from Tehran who suddenly finds himself adrift in a confusing, hostile, and almost engulfing Paris, quite different from the City of Light in which Taraghi herself has lived since 1980.[19]

In the case of Simin Daneshvar (b. 1921), the most prominent living woman writer during the 1970s and 1980s, readers confront in her fiction and essays a masking both of personal feelings and experiences and of political views. For example, in "A Letter to the Reader" (1988), appended to a collection of stories in translation called *Daneshvar's Playhouse* (1989) and written in Tehran where she lives, Daneshvar understandably avoids mention of constraints on writers and literary expression in the Islamic Republic of Iran while castigating capitalism and Marxism. In "Ghorub-e Jalal" (Jalal's Sunset, 1981), she presents details of personal circumstances which are contradicted by her husband Al-e Ahmad's frank account in *A Stone on a Grave*.[20]

The cases of Taraghi and Daneshvar imply that there may not be significant, necessary differences between Iranian literary men and women with respect to self-masking, although women

would naturally face greater social risks in being candid in writing than would men. At the same time, the arena of literary autobiography exhibits differences between the situations of literary men and women better than biography. At first glance, biography and autobiography seem inextricably intertwined or at least closely related. But according to the historian Karl Weintraub, there are significant differences: "The essential subject matter of all autobiographic writing is concretely experienced reality and not the realm of brute external fact. External reality is embedded in experience, but it is viewed from within the modification of inward life forming our experience; external fact attains a degree of symptomatic value derived from inward absorption and reflection. In biography this process is reversed: an outsider to a life tries to discern an inner structure of a life from an assembled mass of data on actualized external behavior and conduct or from the externalized statements of inward life."[21] These differences between autobiography and biography imply that a given literary culture might lack one species while having the other, or that, as in the Iranian case, literary men might engage in autobiographical writing whereas women might not.

A dozen or so Iranian women have now published autobiographies that share characteristics of interest from a literary perspective. First, the majority of these writers are members of the ruling elite, whose womenfolk have special protection and presumably can get away with such individualistic behavior as autobiographical writing, which other Iranian women presumably cannot. Second, the majority of their works are defenses of or apologies for a life lived in the public eye in a particular way. By implication, readers would have a prior interest in knowing about the lives of these women—among them a king's daughter (Taj os-Saltaneh, *Khaterat*, 1982), a king's second wife (Soraya Esfandiyari, *Soraya: The Autobiography of Her Impe-*

rial Highness Princess Soraya, 1963), and a king's twin sister (Ashraf Pahlavi, *Faces in a Mirror,* 1980). In all cases, the women got where they were when inspired to write about their own lives because of their relationships with men. In contrast, literary Iranian women writing of their own lives might appeal to potential readers primarily on the basis of what they as women might write, regardless of who their menfolk are. Most interesting and understandable is the fact that these Iranian women autobiographers are not literary women.

There are a dozen or more relatively prominent literary women in twentieth-century Iran, chief among them Mahshid Amirshahi, Simin Behbehani (b. 1921), Simin Daneshvar, Parvin E'tesami, Forugh Farrokhzad, Zhaleh Qa'emmaqami, Tahereh Saffarzadeh, Goli Taraghi (b. 1939), and Zanddokht Shirazi. The most famous among them, and the only one who has used her life in her art in a way that might be deemed primarily or essentially autobiographical, is Forugh Farrokhzad.

Farrokhzad's use of poetry as autobiography is explained in part by the differences between Iranian literary men and women in terms of their attitudes toward autobiography. Unlike their female counterparts, Iranian literary men have not turned their backs on autobiography. In fact, autobiographical writing constitutes an extremely significant and highly developed medium on the Iranian literary scene for contemporary male authors. Such varied writings as Jalal Al-e Ahmad's *Khasi dar miqat* (Lost in the Crowd, 1964) and "Masalan sharh-e ahvalat" (An Autobiography of Sorts, 1968) are patently autobiographical. Hushang Golshiri's *Keristine va Kid* (Christine and Kid, 1971) is clearly autobiographical, even if presented as a novel; in fact, it fails as fiction because it is not fiction. Golshiri also wrote an autobiographical sketch for *Major Voices in Contemporary Persian Literature* (1980), as did Gholamhosayn Sa'edi, whose autobiographical interview from exile in Paris was published

posthumously. M. E. Beh'azin (b. 1915) is autobiographical in *Mehman-e in aqayan* (Guest of These Gentlemen, 1970), a description of his arrest and incarceration by the Pahlavi authorities. Nader Ebrahimi's *Ebn-e mashgheleh* (Workaholic, 1975) reviews his career. Reza Baraheni's *Safar beh mesr va Halat-e man dar safar* (My Trip to Egypt and My Experiences on the Journey, 1972) was inspired by Al-e Ahmad's *Lost in the Crowd*. The same holds for two autobiographical travelogues by 'Abbas Pahlavan about journeys to Mecca and Esfahan (1973). Baraheni also authored several *romans a clef* and a volume of autobiographical reflections called *Kimiya va khak* (Alchemy and Earth, 1984). For that matter, even Sadeq Hedayat's *Buf-e kur* (The Blind Owl, 1937, 1941) may be more autobiography than fiction.[22] Nima Yushij's practice of keeping copies of all of his hundreds of letters and Sadeq Chubak's (b. 1916) volumes of journals are other sorts of literary autobiography. Such poems as Sepehri's "Seda-ye pa-ye ab" (Water's Footsteps, 1964) may qualify as autobiography. The list, which could go on and on, intimates that modernist male Iranian writers, though generally disinclined to biography, seem almost impelled to autobiographical writing.[23] But no literary women are on the list.

In 1955, Forugh Farrokhzad published the first volume of verse in the history of Persian literature exhibiting a poetic speaker recognizable throughout as a female. Called *Asir* (Captive), it was also the first book of poetry ever published in Iran by an Iranian woman on her own. It and Farrokhzad's four following collections of poems—*Divar* (The Wall, 1956), *'Esyan* (Rebellion, 1958), *Tavallodi Digar* (Another Birth, 1964), and *Iman biyavarim beh aghaz-e fasl-e sard* (Let Us Believe in the Beginning of the Cold Season, 1974)—remain the most discussed books of original writing by an Iranian literary woman.[24]

As if the unprecedented publication of *Captive* and succeeding volumes were not enough, Farrokhzad's own life drew much attention because of its equally unprecedented features. In 1952, she married at the age of seventeen out of love and a desire to escape from a stern father. The following year, she had a son called Kamyar. Not long thereafter, she had a brief affair with a magazine editor in Tehran. At twenty, she sought divorce in order to have the freedom to develop as a poet and person. Accordingly, she was obliged to give up her son to the custody of her ex-husband's family. She later entered into relationships with a number of men. She spoke her mind on whatever topic came up in private or public. In mid-1958 she fell in love with Golestan, a prominent and controversial Tehran intellectual, and spent the last eight years of her life in a relationship with him, conducted openly in the same circle of persons of which Golestan's wife and children were a part. In short, from 1955 onward, Farrokhzad faced considerable antagonistic social pressure and community opprobrium and was the subject of much gossip, even in print. Her unconventional life ended prematurely in a fatal automobile accident in Tehran in 1967 not long after her thirty-second birthday.

Farrokhzad always asserted a special connection between her life and her poems, which signals their potentially autobiographical character. Early in her career, Farrokhzad wrote: "If I have pursued poetry and art, it has not been as a hobby or amusement. I consider poetry and art my whole life." This attitude implies that the poet would put much of her life into her poetry. In 1964, Farrokhzad stated: "Poetry is a serious business for me. It is a responsibility I feel vis-à-vis my own being. It is a sort of answer I feel compelled to give to my own life. I respect poetry to the same extent that a religious person respects his or her religion." If she were to be true to this view, Farrokhzad's poetry would have to be honest, unposturing, and reflective

of her innermost thoughts and feelings. She went on to say: "Poetry for me is like a friend . . . with whom I can easily unburden my heart. It is a mate who fulfills me, satisfies me, without upsetting me."[25] The comment implies that her poetry would be open, frank, and intimate. The fact is that Farrokhzad's poetry reflects and mirrors her life, often directly.

The case of Al-e Ahmad, the one other literary figure of the day whose own life directly embodied the essential contours of his age and who perhaps sensed that connection by gravitating toward autobiography in his essays and stories, is relevant to Farrokhzad's situation by virtue of the fact that he did not distinguish between fictional and nonfictional narrative modes. When he wrote short stories, he was recording personal observation and experience almost exactly as they happened.[26] With the posthumous publication of *A Stone on a Grave* in 1981, readers had incontrovertible evidence of this connection. In other words, this remarkable autobiographical narrative demonstrates that *Modir-e madraseh* (The School Principal, 1958), the most highly regarded novel of its day, is directly autobiographical, as are his other narratives, from his first short story "Ziyarat" (Pilgrimage) in 1945 down to his last major piece of fiction, *Nafrin-e zamin* (Cursing of the Earth), which was completed in 1968 but banned by the Pahlavi regime until ten years later.[27]

The relevance of Al-e Ahmad's prose writing to Farrokhzad's verse lies in the fact that in literary biography, to use the words of Hayden White, "We make sense of the real world by imposing on it the formal coherence we customarily associate with the products of writers of fiction."[28] Or as Susanna Egan puts it, the effective autobiography employs myths, archetypal forms, and metaphors "as efficient purveyors of personal meaning . . . Autobiography is fictive in its turning to these forms in order to say whatever is more than commonplace."[29] Al-e Ahmad's

practice shows that such merging of the novel and autobiography can be natural in Persian literature. In the case of Farrokhzad, the merging is of diary and lyric verse or, more generally, of autobiography and poetry, as in the famous case of William Wordsworth's *The Prelude.*

Treating lyric verse as autobiography, however, is not unproblematic. As Weintraub argues, although "lyric poetry rarely can be free of strong autobiographical elements . . . the autobiographic factor in such poetry very rarely is 'a life,' more frequently it is but a moment of a life, and only sometimes indeed is it a significant moment summing up the quintessential meaning of a life."[30] While this view is valid in general, Farrokhzad's lyric verse qualifies as autobiography owing to its special form and circumstances. First, Farrokhzad herself claimed that poetry was a mirror for her. Second, Iranian readers have almost uniformly construed Farrokhzad's personal comments and reflections in verse as unadulterated autobiographical truth. Third, the vast majority of her poems exhibit the same personal speaker representing, reflecting upon, and responding to immediate events in a life that strikes readers as the poet's. The controversy that Farrokhzad's personal, modernist poetry aroused in the mid-1950s was owing chiefly to the view on the part of readers that a woman poet ought not to be as open, candid, and personal ("unveiled")—in short, as autobiographical—in print as Farrokhzad was. Fourth, when Farrokhzad's autobiographical poems are read in chronological sequence, they seem to constitute a life, even in Weintraub's terms.[31] Fifth and perhaps most significantly, as a woman poet in an Iranian environment in which women did not behave individualistically in public, did not speak candidly in public about their personal thoughts and feelings, and did not appreciate or announce their individuality, almost every poetic situation that arose for Farrokhzad seemed to have in it a need on her part to relate a particular moment,

incident, or mood to the context of her whole life and its meaning.

In Farrokhzad's poetry, readers learn about her childhood (playing with her sister, shopping with her mother), her youth (puberty, interest in romance), her young adulthood (love, marriage, motherhood, divorce), her love relationships (concern about the price she had to pay for living an independent life), her world view, her conception of poetic art, and her politics. Readers are apprised of moods, doubts, fears, beliefs, and dreams that are as explicit and detailed as what they might learn from their closest relatives and friends.[32]

A further problem or issue arises in treating Farrokhzad's verse as autobiography. Although in her poetry Farrokhzad rejects or discards the veils that her society and culture wove for her and refuses to use the sort of mask that serves to hide personality from view, her poetic voice is a persona or mask and not the actual person of Farrokhzad. Therefore, Farrokhzad's attitudes toward her personal life must be distinguished from her attitudes toward her persona in her poetry. Her persona wears a mask, to be sure, but an almost unique mask among Iranian writers, which highlights the autobiographical point of Farrokhzad's poems and her distinctive perspective as an intellectual.

The point is that even if Farrokhzad's life had been conventional, she would still have become more directly autobiographical than other literary women merely by discarding the veils that her culture planned for her to wear, and she would still have become more directly autobiographical than literary men by removing the masks that Iranian literary artists routinely utilize. As it is, she tells readers in unequivocal terms that her poetry is for her a mirror and a mate, two metaphors for situations where one wears neither veil nor mask, where one appears naked and expects to be seen thus by oneself or another.

In her poetry, there are significant autobiographical details that need to be appreciated as such to understand a poem's point. Readers cannot imagine any hypothetical "you" as the person addressed in "She'ri baraye To" (A Poem for You); they need to know that the person addressed is a woman poet in a particular cultural environment who has been obliged to give up her son to pursue her art. In "Bazgasht" (Return) a child character called "Kami" appears. In "Shekufeh-ye anduh" (Blossom of Sorrow), the city of Ahvaz, where Farrokhzad lived when married, the Karun River there, and Farrokhzad's "first love," Parviz Shapur, are pictured almost as in a snapshot. In "Qahr" (Breaking Off), she appears to be giving Nader Naderpur a piece of her mind.[33]

It may even be difficult for a reader to appreciate fully the last stanza of "Tavallodi digar" (Another Birth) without knowing that her employer and lover, Golestan, may have spent much time at the house he put at Farrokhzad's disposal but presumably went back to his own nearby home at night, leaving the poet alone to await a kiss in the morning:

I know a sad little fairy
who lives in an ocean
and ever so softly
plays her heart into a magic flute
who dies with one kiss each night
and is reborn with one kiss each dawn.[34]

Differences between Farrokhzad's autobiographical poetic stance and the more typical Iranian masked personae become apparent in the contrast between her early quatrain sequence lyrics and the ostensibly similar love lyrics by Nader Naderpur, such as his "Chashm-e bakht" (The Eye of Fate), which he actually composed on the subject of his brief relationship with Farrokhzad in late 1955:

Without you, o you who are still in my heart,
without you, the story of my love became the talk of the town.
Without you moments passed, and days.
Laughter turned without you to tears.

Without you, this heart which beat with yours,
how it moaned and moaned and moaned.
Without you, the hand of my blind fate
poured tears and blood into the goblet, not wine.

My life was a black and starless night;
your eyes became its stars,
for a moment appearing from the roof of the clouds,
in a moment sinking into the clouds' mouths.

In the light of these transient stars
came days of joy and sorrow.
The former remained but an instant,
the latter stayed forever, forever.

The sky was envious, and the eye of my fate
shone like the stars of your eyes and died.
Without you, songs fled my lips.
Sparks died in my look, without you.

O you, o you are in and with me always,
alas that I despair of seeing you again!
You are a flower, the flower of my eternal spring.
I have thus no desire to pluck you![35]

In this poem, Naderpur avoids both literary and personal embarrassment by cloaking his true feelings in conventional metaphor and stylized, idealized images of sky, garden, and romance. He says things that are literally untrue for the sake of what he considers to be emotional or poetic truth.

As for Farrokhzad's characteristically personal and autobio-

graphical poetic mode, it is typified by either "Breaking Off" or the poem "Khaneh-ye matruk" (The Abandoned House), composed in early 1955 about a year before Naderpur's "The Eye of Fate." In "The Abandoned House," she reaches poetic truth by dealing with literal truths:

> I know that now from that distant home
> life's happiness has flown away.
> I know that now a child in tears
> grieves at separation from his mother.
>
> The picture of a cold and empty bed
> races through my imagination, and
> the image of a hand that hopelessly searched
> with sorrow and pain for a form there.
>
> I see there beside the space heater
> an indistinct and tremulous shadow,
> the shadow of arms that seem
> to let go of life without a struggle.
>
> Farther away a sad child sleeps
> in the arms of a tired and old nursemaid.
> On the carpet's pattern of flowers
> a cup of milk has spilled over.
>
> The window is open and in its shadow
> the flowers' colors have turned to yellow.
> The curtain has fallen over the door frame.
> The water in the flower pot has dried up.
>
> With a cold and lightless look, the cat
> takes steps softly and heavily;
> in its own last flicker, the candle
> sets out towards nothingness.

> I know that now from that distant home
> life's joy has flown away,
> I know now that a child in tears
> grieves at separation from his mother.
>
> But distressed and weary of spirit,
> I head toward desire's road.
> My lover is poetry, my solace is poetry.
> I am going to seek my lover.[36]

The difference in approach between Naderpur and Farrokhzad is thus seen to be substantially in terms of autobiography. Naderpur's lack of candor per se does not determine whether or not his poem is effective. Because the English-speaking world remains in the middle of a golden age of biography and autobiography, to imply criticism of Iranian culture for lacking either literary species would be just another manifestation of supercilious or insidious ethnocentrism. Nevertheless, Naderpur's refusal to be individual or wholeheartedly modernist in his verse and Golestan's attitude toward biographical inquiry may intimate a failure to appreciate history, in particular the Renaissance, and how and why it led to biographies of their husbands by Lucy Hutchinson and Margaret Cavendish, to Godwin's memoir of his wife Mary Wollstonecraft, to Mrs. Gaskell's biography of Charlotte Brontë to Virginia Woolf's autobiographical writing, and to Maya Angelou's *I Know Why the Caged Bird Sings*.

Hundreds of biographies and autobiographies of women have appeared in the English- and French-speaking world over the years. For example, the publication in 1975 of Ruby Redinger's psychobiography *George Eliot: The Emergent Self* was reportedly the twenty-sixth book-length study of the Victorian novelist.[37] In contrast, many Iranian readers have yet to read their first biography in Persian of an Iranian literary figure, male

or female, or their first autobiography of an Iranian literary woman.

Farrokhzad has paved the way with her own autobiography in poetic installments. It is hard to think of another Iranian poet in any age who described his or her feelings about his or her own life and life's work as directly as Farrokhzad. From her misgivings in "Vahm-e sabz" (Green Delusion) to her vibrant victory in "Conquest of the Garden," from her expression of minimal wants in "Panjereh" (Window) to her defiance in "Tanha seda'st keh mimanad" (It Is Only Sound That Remains), and in that autobiographical road map called "Iman biyavarim beh aghaz-e fasl-e sard" (Let Us Believe in the Beginning of the Cold Season), Farrokhzad attempts and achieves unprecedented feats in Persian lyric poetry.[38]

Should it turn out in the future that poets who lived before Farrokhzad actually paved the way that Farrokhzad is here given credit for, two points are relevant. First, the existence of such autobiographical impulses in literary women before Farrokhzad would be encouraging news for Iranian culture, because they would make more likely the eventual victory of the values for which she stood as an autobiographical voice.[39] Second, since at this point her autobiographical voice is still unprecedented in Persian literature, her unveiled and unmasked poetic persona may literally have made possible the publication of the verse of such women poets as Zhaleh Qa'emmaqami in 1966/7 and Zanddokht Shirazi in 1967, while attracting attention and opening doors to women's poetry in general in the 1960s, a period that has been called "The Decade of the Poetesses."[40] In the case of Zhaleh Qa'emmaqami, there is the further fact that she abandoned more conventional forms and subject matter in her later verse but then threw those poems into the fire (acquiescent veiling); her son had to publish her *Divan* (Collected Poems) without them.

What Farrokhzad brought to the Iranian literary scene was a dramatic and challenging individuality.[41] In contrast, her literary contemporaries, except for Al-e Ahmad, were unprepared to unmask themselves enough to allow their individuated visages to become visible or, in the case of women, were also unable or unwilling to remove their veils. The significance of this development to Iranian literature is underscored by the fact that in the West autobiography came center stage only with the age of Goethe when, according to Weintraub, intellectuals began to feel that "each life, as a time-time and one-time-only actualization of . . . indefinitely variable human potential is marked by an irreplaceable value."[42] A lack of conviction as to the worth of nonroyal, nonimamic individual life has long seemed endemic in Iranian culture.

Given such a cultural context, Farrokhzad's unswerving commitment to the integrity of her autobiographical voice—unlike Taj os-Saltaneh, she had no royal refuge or protector and was not about to wait sixty years for her thoughts to be read—was revolutionary in the annals of Persian literature and Iranian culture. Appreciation of her achievements is still impeded by the kinds of sexist bias found in much critical writing about women poets, including, to use the terminology of Joanna Russ, the denial of agency, pollution of agency, double standard of content, various sort of false categorizing, myth of the isolated achievement, and anomalousness.[43]

Farrokhzad's poems have been more often labeled confessions than autobiography. Farrokhzad the poet has more often been called Farrokhzad the individualist, Farrokhzad the kept woman, Farrokhzad the whore. Among the first serious commentaries on Farrokhzad's poetry were two features in *Khandaniha* magazine.[44] The artwork accompanying one article consisted of a silhouette sketch behind the printed text of a naked female torso. The text of the second article included a

photograph of Brigitte Bardot, with a caption quoting her views about appearing nude on the screen. Critics refer to Farrokhzad by her given name, while referring to other modernist poets by their surnames or pen names (Farrokhzad never used a pen name, as have Ahmad Shamlu, Mehdi Akhavan-e Sales, and others). Traditionalist critics, challenged by Farrokhzad's later poems, are quick to accept her early poems. Some modernist critics, including feminists, call her early work "juvenilia" while applauding her later work. Some of those who accept Farrokhzad as a great modernist argue that Golestan's influence on her was crucial (although he has never published a poem, nor has his wife of forty-five years, nor have his close friends in England during the last decade). The fullest praise for Farrokhzad in the *Khandaniha* articles came in the declaration that her verse was reminiscent of Bilitis's. But Bilitis was a fraud, the product of the imagination of a Frenchman who wanted to create a competitor for Sappho of Lesbos. Farrokhzad was thus praised for resembling what a European scholar thought a Greek poetess of the sixth century BCE would have been like.

Even as sensitive and sympathetic a critic as Farrokhzad's friend Karim Emami may fall prey to a conventional bias in opining that Farrokhzad's greatest contributions are her love poems, thereby assigning her to a less central niche in the pantheon of Iranian poets.[45] More relevant male poets, it is assumed, would deal with history, as in Akhavan's "Shush-ra didam" (I Saw Susa), politics, as in Shamlu's "Dar in bonbast" (In This Deadend), and grand philosophical issues, as in Sepehri's "Water's Footsteps."[46] These poems are appealing and revealing, to be sure. Yet a century hence the unveiled and relatively unmasked verse of Forugh Farrokhzad, which uses images of love to bring alive issues of her life and her art, will likely have the more secure place in the minds and hearts of lovers of Persian poetry. Farrokhzad's unveiled and unmasked poetic

modernism and individuality have opened the way for Iranian poets henceforth to choose without inhibition specific poetic modes for their poetic effects and not to feel conventional fear of social, political, or cultural consequences. A neoclassical Persian poem may make it in the next century, not because it is blessed by convention or displays a stylish veil and a sophisticated mask, but only because it works in a particular poetic situation.

More important, Forugh Farrokhzad has unveiled personal individuality in the Iranian arena. Iranian establishment leaders—whether religious, leftist, or royalist, whether in Tehran, Paris, or Los Angeles—can have few greater fears than that other Iranians will sooner or later emulate what she has done.

· FOUR ·

Half-Voices:
Persian Women's Lives and Letters

WILLIAM L. HANAWAY

In the history of Persian literary writing women always spoke softly, literature being a man's world. In Iran it was natural that a man's words be thought of as an extension of himself in public, and that he utter them at full voice, since public life was a man's domain and women lived behind the veil. On the few occasions when Persian women spoke for themselves in autobiographies or other forms, it was definitely *mezza voce*. A woman's words as an extension of herself in public were always felt by men to be subversive. Women were allowed no words in public, and therefore they were allowed no presence in public.

This was true for the history of Persian writing up to the end of the Second World War. In the thirty years between the end of the war and the beginning of the Islamic revolution in 1978, social changes accelerated, and access for women to education, travel, and public life was greatly expanded. Women, especially in Tehran, were more in the open and visible, and women's words were often heard in public. They wrote literary works and got them published. They made films, acted on the stage, and entered politics. When acting in the movies or on stage, they had to reveal their bodies and voices. When they entered politics, worked in shops, offices, or banks, and interacted publicly with men, at least some of their words had to be heard.

With all these social changes, however, Iranians never ceased to maintain their sense of boundaries, the dividing line between their public and private worlds. Partly due to this sense of the public and the private, and partly due to the masking, women did not write autobiographies, and men did not write biographies of men or women.

If one is to believe novelists and poets, at least Western ones, they reveal their private worlds by baring their selves and souls in an agonizing fashion when they write. Poets often speak of how frightening it is to publish their poems because of what they have revealed of themselves to the sensitive reader. This is nothing but an expression of the sense of boundaries that Western writers and readers feel. Persian women who write also bare their souls, but even in the 1960s and 1970s they did not write autobiographies. From the Western point of view, a writer does not necessarily reveal more of herself in an autobiography than in a poem or a work of fiction, or than in acting on the stage or in films. For Persian women, however, there is a barrier to making direct autobiographical statements. Perhaps it is the fear of what might be revealed, rather than the fear of making her voice heard at all, that brings about the veiling and the self-censorship. Maybe it is a fear of revealing what lies on the other side of the line between public and private, and thus committing the ultimate act of subversion.

One notable exception to these generalizations about women and autobiography is the autobiography of the Qajar princess Taj os-Saltaneh. This work raises the question of what the author might have used as a model, there being no indigenous tradition of women's autobiography. It is plausible to suggest that European fiction writing was the model. Fiction is a way of structuring reality, a way of perceiving and conceiving the world. The conventions of fiction determine in many ways how we process, transmit, and interpret experience for the written

page. By 1914, the year in which Taj os-Saltaneh completed her autobiography, few works of European fiction had been translated into Persian, and even fewer novels had been written in Persian. Both those that had been written in Persian and those translated from European languages resembled in many ways popular Persian storytelling. They were long, action-packed, episodic tales in the style of *Samak-e 'Ayyar* or the nineteenth-century romance *Amir Arsalan*.[1] The characters were types more than individuals, and no significant psychological development was portrayed in the heroes and heroines. The novels of Alexandre Dumas, for example, were very popular in Persian translation. In spite of certain formal resemblances in Persian and French fiction, however, the world was perceived, or constructed, quite differently in them. Traditional Persian fiction would not have been a productive model for a twentieth-century Persian noblewoman to use in writing her autobiography. Taj os-Saltaneh had presumably been reading other sorts of fiction, most likely in French.

There is a curious parallel between Taj os-Saltaneh's autobiography and the autobiography titled *Sharh-e zendegani-ye man* by the Qajar bureaucrat 'Abdollah Mostowfi.[2] Like Taj os-Saltaneh's autobiography, Mostowfi's contains detailed descriptions of natural settings and social situations. The author, who completed his work in 1942, tries to explain events in a rational fashion for the reader, just as Taj os-Saltaneh does. This approach could have been the result of his having read European literature, but whatever the case, Mostowfi wanted to write a history of his times and to show his role in it. While his aim differed from that of Taj os-Saltaneh, who seemingly wanted to set down some details of her private life, both of them had to organize their information, including their own memories of the past, in some fashion. Hayden White states that "we make sense of the real world by imposing on it the

formal coherence we customarily associate with the products of the writers of fiction."[3] With no indigenous narrative tradition that would provide models for this purpose and with scarcely any examples of autobiography, European fiction could have been an influential factor for both authors in writing their autobiographies.

Genres are a kind of contract between the writer and the reader: a set of mutually agreed-on rules and guidelines that are flexible and ever-changing but at the same time always recognizable. They impose certain responsibilities on the writer and raise certain expectations in the reader. In the Western tradition, novels and autobiographies are generically distinct. Susanna Egan argues, "autobiography is fictive in its turning to these [fictional] forms in order to say whatever is more than commonplace."[4] But to characterize autobiography as fictive because it uses the conventions of fiction to make the undifferentiated mass of an individual's experience coherent and intelligible is not to say that autobiography is fiction. This is the point where generic boundaries touch, but for the Westerner, fiction and autobiography must remain separate. The novelist presents one view of experience, and the biographer, autobiographer, and historian present a different view, because their aims are dissimilar, their methods vary, and their genres impose different constraints on them. One creates a world; the others try to make sense of the world.

The case of Forugh Farrokhzad is somewhat different. It may be correct to call her a modernist for her willingness to shed her veils and masks and openly reveal her inner feelings. That she was able to do this in her poetry is significant, but it does not make her poetry autobiography. A salient characteristic of autobiography in the Western tradition is that the writer attempts to place his or her life in a longer perspective, much as a biographer does. The autobiographer looks back from middle or old

age and interprets the facts of his or her life, shaping them into an overall pattern which gives meaning to them as a whole. Weaknesses and darker aspects of the life are not suppressed, and the emphasis is not on making a public image but rather on trying to understand the meaning of the life in its context. The result of this effort is not a generic merger of the novel or lyric poetry with biography. Autobiographies may be fictive, but if they are honest, they are not fiction.

To introduce a parallel example, Robert Frost and Emily Dickinson put a great deal of their inner and outer lives into their poetry, but we are not able to reconstruct their lives from reading their poems. Nor, in my opinion, can we do this for Farrokhzad. To be sure, we can relate certain attitudes and statements in her poems to certain information that we have about her life, but this is generally a matter of association, allusion, and inference. One fundamental obstacle to considering her poetry as an autobiography is that it has no narrative which could give meaning to the scattered "facts" that appear there. It is through narrative that facts or experiences are organized and given meaning in any representation of reality. The narrative traditions and conventions of a culture shape the writing of its history, biography, and autobiography. Even if Farrokhzad's poems could be considered as micronarratives that organize certain "facts" or experiences (and I do not believe that they can be), their very paucity and disconnectedness would make it impossible to consider them all together as a narrative and therefore as an autobiography. Her poetry as a whole does not establish enough of a context into which to fit all of the individual "narratives" and thereby give them meaning. The reader who knows something of Farrokhzad's life can begin to do this, but the process is then something other than autobiography.

The fact that Iranian culture has no tradition of biography and autobiography as we know them in the West does not mean

that the would-be biographer has no models at all to look to in writing his or her own life or the life of another. For example, a number of biographies have become influential in Persian culture and literature. The most prominent of these are biographies of Alexander the Great, the central figure of Iranian Shiism; Imam Hoseyn; and Ferdowsi, the tenth-century author of the national epic titled *Shahnameh*. Their life stories have been told many times in many literary genres through the centuries. For the most part, this sort of life writing conforms to the view of biography as an example or model of moral and didactic value for readers.[5] The moral and didactic value of the life of Imam Hoseyn for Iranian Shiites is central to their view of themselves and the world. This has been amply illustrated by the statements and deeds of the Iranian leadership since the Islamic revolution. Alexander the Great's life is used as an example of ideal kingship and of the values that Iranians associate with that institution. Ferdowsi's life has become a model of moral strength and perseverance in the face of injustice, a theme that is prominent as well in the life of Imam Hoseyn.

The figures in these biographies are all larger than life: many have become the subject of legend or even myth. In a literary culture that resists producing biographies today, these are important examples of biography from the past. Biographies of another sort are found in *tazkereh*s, the biographical compendia of poets, sufis, and other classes of persons. The lives of "saints" and panegyric odes generally present the same sort of model, emphasizing the moral and didactic value of the life for the reader. Not until the middle of the twentieth century were biographies written, such as that of Shah 'Abbas I, which attempt to be factual and objective in the Western fashion.[6]

There are even fewer models of autobiography in Persian literature. Naser Khosrow's *Safar Nameh* is not an autobiography but a travel account that covers about seven years of a fairly

long life.[7] There are other travel accounts by Qajar officials, Taj os-Saltaneh's autobiography, and the autobiography of Mostowfi, which is subtitled "A Social and Administrative History of the Qajar Period." The autobiography of the late shah was ghostwritten by an American.[8] Although there are certainly other autobiographies, their number is small, and it is clear that this genre is not a favorite one in Persian literary culture.

In short, there are a small number of biographies of very important males in Persian culture, and these biographies are in the moral and didactic mode. There appear to be no biographies of women. There are an even smaller number of autobiographies, few of which are by a literary figure, and even fewer by a woman. It seems that scholars and government officials are willing to write biographies, but that literary figures are unwilling to write them.

So far, the terms *biography* and *autobiography* have been used here in their usual Western sense. It is possible that the problem has another dimension, namely that certain genres are not transportable. When prominent literary men and women of Tehran in the 1960s and 1970s were experimenting with all sorts of new forms and ideas, it is odd that they did not take up biography, even to write about the lives of figures from the past. Although mastering an imported form is a difficult task, Persian writers have mastered the short story, the novel, and the drama. Yet biography was left to scholars, presumably as a form of history writing. Autobiography suffered a similar neglect.

The reason may be that autobiography is more of a cultural form than a literary genre capable of being transplanted and flourishing in non-Western literary traditions. Autobiography owes a great deal to post-Renaissance thought about the worth of an individual and the uniqueness of a human life. Research on autobiographical memory has confirmed that memory is a

narrative, and that writing about one's own past is always reconstructive rather than recollective.[9] History and biography acknowledge the fallibility of memory, but autobiography depends on one's own memory to reconstruct a past that may be true but may not be accurate.

If memory is a narrative, its structure must be influenced by the structure of other constructed narratives in a culture, the most conspicuous being prose fiction. If fiction provides the narrative structures for Western autobiographies, then Persian fiction should provide them for Persian autobiographies. Yet traditional Persian narrative fiction of the *Amir Arsalan* variety may not have narrative structures and ways of organizing experience that meet the needs of contemporary Iranians. And maybe Western-style fiction is not yet sufficiently internalized in the Persian mind to provide the structures for the literary narration of the events of one's own life in the Western fashion. Iranians do tell their life stories to each other, but the shaping of a narrative of one's own life in literary form is not the same as relating it orally. Maybe all those talented writers, poets, and playwrights of the 1960s and 1970s did not sense that the basic narrative structures were available to them in sufficient force, variety, or depth to allow them to write their own lives and cross the public-private boundary safely. Or maybe they knew the narrative structures well enough and rejected them as culturally inappropriate.

The definition of autobiography used here may be far too Western-centered and culture-bound for Iranians to make use of it. If in fact autobiography is more of a cultural form than a literary genre, then it should be less transportable than a literary genre. The cultural situation in Iran may be closer to the norm for the rest of the world in this respect, and the Western practice may be the exception. After all, Iran did not experience the Renaissance, and while classical thought is one element in Iranian culture, it is not, as in the West, the basic substratum.

It might seem that writers working within the cultural and intellectual tradition of Iran should be ready to produce biographies and autobiographies simply because they have mastered other Western literary genres. The interpretation of Persian prose fiction and lyric poetry as forms of autobiographical writing has a bearing on this question. It is possible that lyric poetry and certain kinds of prose fiction are entirely appropriate forms for autobiographical writing in the Persian literary tradition. Most Persian lyric poetry focuses on classes and types rather than on individuals, so that when a clear personal statement is made, Persians tend to interpret it as true. It remains to be seen whether autobiographical memory operates the same way in Iranians as it does in Westerners. Lyric poetry is, by and large, non-narrative in Persian.

If Western-style autobiography does not suit Persian cultural and literary categories, it then becomes the task of scholars to describe more clearly what are the limits of autobiography as a Persian cultural form. If research begins along these lines, then this book will truly have performed its function.

Notes

1. Veiled Voices: Women's Autobiographies in Iran

This chapter is part of a book-length project, titled "Veils and Words."

1. James Olney, "Autobiography and the Cultural Moment: A Thematic, Historical, and Bibliographical Introduction," *Autobiography* (Princeton: Princeton University Press, 1980), p. 3.
2. Nizami, *Layla and Majnun*, trans. R. Gelpke (Boulder: Shambala, 1978), p. 145.
3. Michael C. Hillmann, *A Lonely Woman* (Washington: Three Continents Press and Mage Publishers, 1987), p. 31.
4. Amin Banani with Jascha Kessler, *Bride of Acacias* (New York: Caravan Books, 1982), p. 132.
5. Simin Daneshvar, *Savushun* (Tehran: Kharazmi, 1969).
6. Shahrnush Parsipur, *Sag va zemestan-e boland* (The Dogged Winter and the Dog) (Tehran: Sepehr, 1976), p. 98.
7. Farzaneh Milani, *"Pa-ye sohbat-e Simin Daneshvar"* (An Audience with Simin Daneshvar), *Alefba*, n.s., no. 4 (Fall 1983), p. 155.
8. Forugh Farrokhzad, *Harfha'i ba Forugh Farrokhzad: chahar goft va shonud* (Conversations with Forugh Farrokhzad: Four Interviews) (Tehran: Morvarid, 1976), p. 12.
9. Mahshid Amirshahi, *Montakhab-e dastan-ha* (Selected Stories) (Tehran: Tus, 1972), p. 4; Amirshahi, *Dar hazar* (At Home) (Encino: Ketab, 1986).
10. Mary Ellmann, *Thinking about Women* (New York: Harcourt Brace Jovanovich, 1968), p. 29.
11. M. M. Bakhtin, *The Dialogic Imagination*, ed. Michael Holquist, trans. Caryl Emerson and Michael Holquist (Austin: University of Texas Press, 1986).

12. Parvin Nowbakht, *Daryache-ye Marivan: Sa'at shesh* (Marivan Lake, at Six O'clock) (Tehran: Sepehr, 1981), p. 18.
13. Ashraf Pahlavi, *Faces in a Mirror* (Englewood Cliffs, N.J.: Prentice-Hall, 1980), p. xv.
14. *Khaterat-e Taj os-Saltaneh* (Taj os-Saltaneh's Memoirs), ed. Mansureh Ettehadiyeh and Cyrus Sa'dvandiyan. (Tehran: Nashr-e Tarikh-e Iran, 1982), p. 5.
15. Marziyeh Ahmadi Osku'i, *Khaterati az yek rafiq* (Memoirs of a Comrade) (n.p.: Sazeman-e Fadaiyan-e Khalq, n.d.).
16. Parvin Nowbakht, *Marivan Lake, at Six O'clock* (Tehran: Sepehr, 1981).

2. A Different Voice: Taj os-Saltaneh

I would like to thank Dr. John Emerson of Widener Library (Middle East Section) of Harvard University for invaluable advice concerning historical texts and other references. My thanks to Colleen MacDonald for helping me through Jules Simon's French writings. I am also indebted to Shireen Mahdavi and Michael Hillmann for their criticism and comments on this chapter. The chapter is part of a book-length project, titled "Unveiling 'the Woman Question': Politics of Modernity and Morality in Contemporary Iran."

1. *Khaterat-e Taj os-Saltaneh* (Taj os-Saltaneh's Memoirs), ed. Mansureh Ettehadiyeh and Cyrus Sa'dvandiyan (Tehran: Nashr-e Tarikh-e Iran, 1982). All page references are to this published version. All translations from Persian to English are mine.
2. Deniz Kandiyoti, "Slavegirls, Temptresses and Comrades: Images of Women in the Turkish Novel," *Feminist Issues* 8, no. 1 (Spring 1988): 35–50.
3. E. G. Browne, in a prefatory note on the manuscript, describes *Sad Khetabeh* as "'A Hundred Homilies' addressed by the (imaginary) Prince Kamalu d-Dawla of India to Prince Jalala d-Dawla of Persia." In fact, only forty-two of these addresses have so far been found. In the Browne Collection at Cambridge University two versions exist in manuscript. One seems to be an earlier, rougher, and harsher version of the more commonly known version. In the second version, sermons 33–35 discuss various issues related to the social situation of women in Iran. These sermons have now been published in *Nimeye digar* (The Other Half), no. 9 (Spring 1989): 101–112. See also Mangol Bayat, *Mysticism and Dissent: Socioreligious Thought in Qajar Iran* (Syra-

cuse: Syracuse University Press, 1982), esp. pp. 157–161; Fereydun Adamiyyat, *Andisheha-ye Mirza Aqa Khan Kermani* (The Thoughts of Mirza Aqa Khan Kermani) (Tehran: Payam Publications, 1978).
4. See Mangol Bayat-Phillip, "Women and Revolution in Iran, 1905–1911," in *Women in the Muslim World*, ed. Lois Beck and Nikki Keddie (Cambridge: Harvard University Press, 1978), pp. 295–308; Roshanak Mansur, "Women in the Constitutional Press" (in Persian), in *Nimeye Digar*, no. 1 (Spring 1984): 11–30.
5. Neither of these two manuscripts has been published. I consulted photocopies of the originals, for which I am indebted to Asadollah Kheirandish and Roxan Zand.
6. Shireen Mahdavi, private correspondence.
7. See e.g. *Nimeye Digar*, no. 6 (Winter 1988); Mansur, "Women in the Constitutional Press."
8. See Mohammad Sadr Hashemi, *Tarikh-e jara'ed va majallat-e Iran* (History of Press and Magazines in Iran) (Isfahan: Kamal, 1949, repub. 1985), II, 266–267.
9. For women's poetry, see Farzaneh Milani, "Love and Sexuality in the Poetry of Forugh Farrokhzad: A Reconsideration," *Iranian Studies*, vol. 15 (1982), pp. 117–128. Questions have been raised regarding the date of this manuscript. The editors of the published version date it to 1924 (p. xii). But the text itself recalls a discussion that Taj os-Saltaneh had on January 27, 1914, with her cousin and teacher, Suleiman, which prompted her to write her memoirs. It seems unlikely that the writing occurred ten years later or took ten years to accomplish. The internal evidence of the memoirs is contradictory. At one point (p. 26), describing her engagement at the age of eight, she talks of the incident as something that happened twenty-two years ago. This would make her thirty years old at the time of writing and would date it to 1913. However, when she discusses the assassination of her father, Naser ed-Din Shah, in 1896 (p. 57), she talks of the incident as something that happened twenty-seven years ago. This would make her forty years old at the time of writing, putting the year at 1923. When she talks of European women fighting for the right to vote and to be elected, she adds that American women have already won the vote and "the same for women in London and Paris" (pp. 98–99). The first state to grant women the vote was Washington, in 1910; the final vote on the matter in Congress occurred on January 19, 1918, and the Senate approved the bill on May 20, 1919. In Britain the final

reading of the bill passed the Parliament on December 7, 1917. Women did not gain the right to vote in France until October 21, 1945. Therefore, the phrase "and the same in London and Paris" could not refer to the winning of the right to vote. Most likely it refers to the existence of strong suffragette movements in those cities. The memoirs speak about these movements of European women in current, contemporary terms rather than as belonging to previous years. This suggests that they were written in the mid-1910s rather than the mid-1920s. Moreover, if she had written them in 1924, she would hardly have ignored such important events as the regime of the last Qajar shah (Ahmad Shah), World War I, and the 1921 coup that brought Reza Shah to power—none of which is mentioned at all. When talking about her family, Taj os-Saltaneh gives the impression not of a dynasty about to be ended, with a virtually powerless absent monarch, but of a family still considered a royal household. The published version is based on a manuscript that was copied from the original, said to be in Taj os-Saltaneh's own handwriting, by a clerk at the Legation of Afghanistan in Tehran in 1924. There is no reason to assume that the copying was done in the same year as the original was written.

Ebrahim Safa'i, "Taj os-Saltaneh," *Rahnemay-e Ketab* 12, nos. 11–12 (Feb.–March 1970): 682–684, has also questioned the authenticity of this manuscript, arguing that Taj os-Saltaneh was too young to have remembered many of the incidents that are recalled in the memoirs, that she was not educated enough to write such a text, and that the style of writing as well as the ideas of the text could not belong to that period. Safa'i offers no evidence to back up these claims, and on the third point he is clearly wrong, because Taj os-Saltaneh's ideas and style of prose fit in well with other autobiographical texts of the period.

10. For other ways in which these memoirs are different, see the editors' "Introduction," pp. vii–xvi; Farzaneh Milani, *"The Memoir of Taj-O Saltaneh," Iranian Studies* 19, no. 2 (Spring 1986): 189–192; Shireen Mahdavi, "Taj os-Saltaneh, an Emancipated Qajar Princess," *Middle Eastern Studies* 23, no. 2 (April 1987): 188–193.

11. This also makes sense within the chronology of what is known of her subsequent years: 'Aref's "gate-crashing," as Mahdavi called it, occurred in the spring of 1905. Her correspondence with an "Armenian freedom-seeker from Caucasia" dates to 1908–09, and her re-

gretful—yet rebellious—memoirs date to some time after 1914. See Mahdavi, "Taj os-Saltaneh," p. 191; Mirza Abolqasem 'Aref Qazvini, *Kolliyyat-e 'Aref* (Collected Poems), ed. Seyf Azad (Tehran: Taban Press, n.d.).

12. See pp. 109–110. Her contradictory feelings pertain not only to herself but also to the person who took charge of breaking her into this new world.

13. Unfortunately it is not known what novels and plays she read or which ones were widely read in the early 1900s. Francois Fenelon, Alexandre Dumas, Jules Verne, Victor Hugo, and Molière were among the earliest writers translated from the French in the late nineteenth century. (Davoud Navabi, *Tarikhche-ye tarjomeh* (History of Translation) (n.p., 1985). Other European writers may have been translated through the intermediary of other languages, such as Arabic and Turkish.

14. Taj os-Saltaneh quotes a full page from one of Jules Simon's books (p. 11). An almost identical passage appears in *Bahar* 1, no. 1 (Mar. 24, 1910): 11, a journal published by E'tesam ol-Molk, but since Taj os-Saltaneh's quote is more extensive, she could not have simply copied it from *Bahar*. And *Bahar* could not have copied it from her, since her memoirs were written after 1914. One possibility is that a translation of the book then existed from which both authors drew their quotations.

15. Qasim Amin's *The Emancipation of Women*, published in Cairo in Arabic in 1899, was translated by E'tesam ol-Molk into Persian and published in 1900, under a different title, *Tarbiyat-e nesvan* (The Education of Women). See Yahya Aryanpur, *Az Saba ta Nima* (From Saba to Nima) (Tehran: Jibi Books, n.d.), p. 113.

16. Cf. Safa'i, "Taj os-Saltaneh," p. 684, which deprives Taj os-Saltaneh of credit for her "moral corruption," attributing her free relations with men not to a change in ideas brought about by her reading, her naturalist inclinations, and her irreligiosity, nor to her bitterness toward her husband (as she implies herself), but to a gang rape carried out by a group of young aristocrats.

17. Kermani, *Sad Khetabeh,* sermon 35.

18. Mahdavi, "Taj os-Saltaneh," p. 191.

19. Cf. Milani, *"The Memoirs of Taj-O Saltaneh,"* p. 191, which argues that, "Anticipating future fashions in popular demonology, when Taj-O Saltaneh cannot pinpoint a specific culprit, she blames all the

ills and malaise of her personal life on the overvalued/devalued, idealized/demonized West. Progressively, her indictment against the West becomes more serious and, with her increasing frustrations, it takes on a mystical quality." But Taj os-Saltaneh invariably speaks in admiring terms about Europe and European women. The only place she comes close to using Europe as a scapegoat is toward the end, where she connects her separation from her husband to her desire to travel to Europe. But even here she blames herself for her desire and, indirectly, those people around her who were responsible for creating that desire, but not Europe itself.

3. An Autobiographical Voice: Forugh Farrokhzad

1. See Reza Baraheni, "Ta'ammolati piramun-e she'r va nasr" (Reflections on Poetry and Prose), *Negin*, no. 105 (30 Bahman 1974): 9–11, 49–51; repr. in no. 168 (31 Tir 1979).
2. M. F. Farzaneh, *Ashna'i ba Sadeq Hedayat* (My Acquaintance with Sadeq Hedayat), 2 vols. (Paris, 1987), treats the last years of Hedayat's life, but so barbarously that the material has little biographical value. As M. Razin, *Iranshenasi* 1, no. 2 (Summer 1989): 405–412, observes, the very fact that Farzaneh did not write and publish his work until some thirty-seven years after Hedayat's death bespeaks the characteristic reticence or reluctance on the part of literary Iranians to engage in literary biography.
3. Conversation with Carter Bryant, San Francisco, November 1984.
4. A. Mahyar, "Babr dar qafas-e zarrin" (A Tiger in a Golden Cage), *Mahnameh-ye Par*, no. 20 (September 1987): 33.
5. Letter from Kambiz Gowtan, Paris, 18 October 1984.
6. Letters to the author, 9 September 1982–24 December 1987, in response to drafts of chapters of *A Lonely Woman: Forugh Farrokhzad and Her Poetry* (Washington, D.C.: Mage Publishers and Three Continents Press, 1987) and other essays treating Farrokhzad and her poetry.
7. Soraya Paknazar, "*A Lonely Woman*," *American Book Review* 11, no. 3 (July–August 1989): 8.
8. Baraheni, "Reflections."
9. Farzaneh Milani, "Power, Prudence, and Print: Censorship and Simin Daneshvar," *Sociology of the Iranian Writer*, comp. and ed. Michael Hillmann, *Iranian Studies* 18, nos. 2–4 (1985): 328–329, implies that the reasons for the lack of biographical writings do not differ in the

case of literary women: "A biography of [Simin] Daneshvar [Iran's most prominent living woman author] does not exist, for basically the same reasons accounting for the dearth of biographies of Iranian literary figures in general."

10. Heshmat Moayyad, "Parvin's Poems: A Cry in the Wilderness," *Islamwissenschaftliche Abhandlungen* (Wiesbaden: Franz Steiner Verlag, 1974), pp. 164–190; Moayyad, trans., with Margaret Madelung, *A Nightingale's Lament: Selections from the Poems of Parvin E'tesami* (Costa Mesa, Cal.: Mazda, 1985), reviewed by L. P. Alishan, "A Nightingale's Lament," *Journal of Near Eastern Studies* 47 (1988): 64–76; *Divan-e Parvin E'tesami* (The Divan of Parvin E'tesami), ed. with an intro. and bibl. by Heshmat Moayyad (Costa Mesa, Cal.: Mazda, 1987); Moayyad, "Bargozideh'ha, beh yad-e hashtadomin salgard-e tavallod-e Parvin E'tesami" (Selections, in Commemoration of the Eightieth Anniversary of the Birth of Parvin E'tesami), *Iran Nameh* 6, no. 1 (Fall 1987): 116–142. Fereshteh Davaran, "She'r-e ghayr-e shakhsi-ye Parvin E'tesami" (Parvin E'tesami's Impersonal Poetry), *Iranshenasi* 1, no. 2 (Summer 1989): 285; quotations taken from the translation of a Persian abstract of the article, pp. 42–43 of the English section of *Iranshenasi*. Moayyad, *A Nightingale's Lament*, p. xi, asserts: "Parvin's life may be described in a few lines. It was simple, unexciting, and without any significant ... events." This characterization is not unlike a popular view of Emily Dickinson's life until given its biographical due. For the reluctance of Iranian scholars to write about the lives of contemporary Iranian literary figures, see Hillmann, *A Lonely Woman*, pp. 147–154.

11. Leonardo P. Alishan, "From the Waste Land to the Imam," *Literature and Society in Iran*, ed. Michael C. Hillmann, *Iranian Studies* 15 (1982): 181–210; Farzaneh Milani, "Conformity and Confrontation: A Comparison of Two Iranian Women Poets," *Women and the Family in the Middle East: New Voices of Change*, ed. Elizabeth Fernea (Austin: University of Texas Press, 1984), pp. 317–330; Milani, "Revitalization: Some Reflections on the Work of Saffarzadeh," *Women and Revolution in Iran*, ed. Guity Nashat (Boulder: Westview Press, 1983), pp. 129–140. In that article Milani observes, pp. 129–130: "Not much is known about Saffarzadeh's life, and it is practically impossible to fully reconstruct it from the meager published information." Although knowledge of Saffarzadeh's life may not seem crucial to an appreciation of her poetry (which would be reason enough for the

literary critic not to write about it), her special life story is important for cultural reasons, and details of it are readily accessible to scholars. That Milani and Alishan choose not to treat the matter may itself constitute further instances of Iranian reticence at biographical inquiry.

12. Conversation with Gholamhosayn Sa'edi, Paris, 19 May 1984; Hillmann, *A Lonely Woman*, pp. 152–153.
13. Conversations with the poet's son Sheraguime Youchidje, Austin, Texas, August 1985 and throughout 1987; Jalal Al-e Ahmad, "Pirmard cheshm-e ma bud" (The Old Man Was Our Eyes), *Aryzabi-ye shetabzadeh* (Hasty Assessment) (Tabriz: Ebn-e Sina, 1965), pp. 37–53, trans. Thomas M. Ricks in *Iranian Society: An Anthology of Writings by Jalal Al-e Ahmad*, comp. and ed. Michael Hillmann (Costa Mesa, Cal.: Mazda, 1982), pp. 99–110.
14. Sadeq Hedayat, *Sadeq Hedayat: An Anthology*, ed. Ehsan Yarhster (Boulder: Westview Press, 1979); Hedayat, *The Blind Owl*, trans. D. P. Costello (New York: Grove Press, 1969).
15. Manoutchehr Mohandessi, "Hedayat and Rilke," *'The Blind Owl' Forty Years After*, ed. Michael C. Hillmann (Austin: Center for Middle Eastern Studies and University of Texas Press, 1978), pp. 118–124.
16. Mohammad 'Ali Sepanlu, "Ketabha-ye tazeh: *Khab-e zemestani*" (Recent Books: *Winter Sleep*), *Ferdowsi*, no. 1124 (August 1973): 28; Goli Taraghi, *Khab-e zemestani* (Winter Sleep/Hibernation) (Tehran: Nil, 1973), trans. Gilles Mourier and Taraghi, *Sommeil d'hiver: roman* (Paris: Maurice Nadeau, 1986), and Francine T. Mahak, "A Critical Analysis and Translation of a Modern Persian Novel: *Winter Sleep* by Goli Taraghi," Ph.D. diss., University of Utah, 1986.
17. Goli Taraghi, "Bozorgbanu-ye ruh-e man" (The Great Lady of My Soul) *Ketab-e Jom'eh* 1, no. 5 (8 Shahrivar 1979): 38–50, trans. Faridoun Farrokh in *Literature and Society in Iran*, comp. and ed. Michael Hillmann, *Iranian Studies* 15 (1982): 211–225.
18. Letter from Goli Taraghi, 31 January 1988: "I long for my native country and dread being away. I feel as if I am trapped in a couchemare. If you read the first part of 'Mr. Alef,' you will understand. For Mr. Alef is me."
19. Goli Taraghi, "'Adatha-ye gharib-e aqa-ye Alef dar ghorbat" (The Bizarre Comportment of Mr. Alef in Exile), an incomplete, typewritten ms.

20. Simin Daneshvar, "Loss of Jalal" and "A Letter to the Reader," *Daneshvar's Playhouse, A Collection of Stories*, trans. Maryam Mafi (Washington, D.C.: Mage Publishers, 1989), pp. 133–153, 155–170. Simin Daneshvar's 1969 novel, translated by M. R. Ghanoonparvar as *Savushun: The Mourners of Siyavash* (Washington, D.C.: Mage Publishers, 1990), is Iran's best-selling work of interpretive fiction ever. This historical narrative set in Shiraz in the 1940s features a woman character who emerges as a heroine. It remains to be seen if Daneshvar's recently completed and still unpublished narrative called *Jazireh-ye sargardani* (Island of Bewilderment), the first scene of which describes her first day back in class at the University of Tehran after her husband's death, will allow readers a glimpse behind authorial masks. Simin Daneshvar, "Bakhshi az roman-e *jazireh-ye sargardani*" (A Passage from the novel *Island of Bewilderment*), *Kayhan-e Farhangi*, no. 6 (Shahrivar 1987): 11.
21. Karl J. Weintraub, "Autobiography and Historical Consciousness," *Critical Inquiry* 1, no. 1 (1975): 822–823.
22. Michael C. Hillmann, "Hedayat's *The Blind Owl*: An Autobiographical Nightmare," *Iranshenasi* 1, no. 1 (Spring 1989): 1–21, English sec.
23. Among autobiographical works available in English translation are: Jalal Al-e Ahmad, *Lost in the Crowd*, trans. John Green with Ahmad Alizadeh and Farzin Yazdanfar (Washington, D.C.: Three Continents Press, 1985); Al-e Ahmad, "An Autobiography of Sorts," trans. Michael Hillmann, *Iranian Society*, pp. 13–19; Gholamhosayn Sa'edi and Hushang Golshiri, *Major Voices in Contemporary Persian Literature*, ed. Michael Hillmann, *Literature East & West* 20 (1980): 144–147, 245–250; Sohrab Sepehri, "Water's Footsteps: A Poem," trans. Karim Emami, *Literature and Society in Iran*, ed. Michael Hillmann, *Iranian Studies* 15 (1982): 97–116.
24. The handiest volume of Farrokhzad translations is *Bride of Acacias: Selected Poems of Forugh Farrokhzad*, trans. Jashah Kessler with Amin Banani (Delmar, N.Y.: Caravan Books, 1982). A dozen or more 2of her chief poems appear in translation in *Forugh Farrokhzad a Quarter-Century Later—Literature East & West* 24 (1988).
25. See Forugh Farrokhzad, quoted in *Harfha'i ba Forugh Farrokhzad: chahar goft va shonud* (Conversations with Forugh Farrokhzad: Four Interviews) (Tehran: Morvarid, 1976), pp. 48, 78.
26. Simin Daneshvar, "Showharam Jalal" (My Husband Jalal), *Ghorub-e*

Jalal (Jalal's Sunset) (Tehran: Ravaq, 1981/2), pp. 11–12; Michael Hillmann, "Cultural Dilemmas of an Iranian Intellectual," *Lost in the Crowd,* pp. i–xxvi.
27. See Michael Hillmann, "Introduction," *By the Pen by Jalal Al-e Ahmad,* trans. M. R. Ghanoonparvar (Austin: Center for Middle Eastern Studies and the University of Texas Press, 1988), pp. v–xxvi.
28. Hayden White, quoted in Ira B. Nadel, *Biography: Fiction, Fact, and Form* (New York: St. Martin's Press, 1984), p. 99.
29. Susanna Egan, *Patterns of Experience in Autobiography* (Chapel Hill: The University of North Carolina Press, 1984). pp. ix–x.
30. Weintraub, "Autobiography and Historical Consciousness," p. 822.
31. Such *engagé* poems as "Ayeh'ha-ye zamini" (Earthly Verses), "Arusak-e kuki" (The Wind-up Doll), "Ay marz-e por gohar" (O Jewel-Studded Land), "Delam barayeh baghcheh misuzad" (I Feel Sorry for the Garden), and "Kasi keh mesl-e hichkas nist" (Someone Who Is Not Like Anyone) may not qualify as autobiography because Farrokhzad therein deliberately speaks as an impersonal social critic or as a character different from herself.
32. Hillmann, *A Lonely Woman,* chs. 1–2.
33. Forugh Farrokhzad, "She'ri baraye to" (A Poem for You), *'Esyan* (Rebellion) (Tehran: Amir Kabir, 1958), pp. 55–60; Farrokhzad, "Bazgasht" (Return), *Rebellion,* pp. 95–100; "Shekufeh-ye anduh" (Blossom of Sorrow), *Divar* (The Wall) (Tehran: Amir Kabir, 1971/2), pp. 107–112; "Qahr" (Breaking Off), *Rebellion,* pp. 131–135.
34. Farrokhzad, "Tavallodi digar" (Another Birth), *Tavallodi digar* (Another Birth) (Tehran: Amir Kabir, 1964), pp.164–169; Karim Emami, "The Poet's Reading of 'Another Birth,' " *Forugh Farrokhzad a Quarter-Century Later,* pp. 73–77; M. R. Ghanoonparvar, "Another Reading of 'Another Birth,' " *Forugh Farrokhzad a Quarter-Century Later,* pp. 79–89.
35. Nader Naderpur, "Cheshm-e bakht" (The Eye of Fate) (dated February 1956, Tehran), *She'r-e angur* (The Grape Poem) (Tehran: Nil, 1958), pp. 65–67, trans. Michael Hillmann, *False Dawn: Persian Poems,* pp. 39–40.
36. Forugh Farrokhzad, "Khaneh-ye matruk" (The Abandoned House), *Captive,* pp. 133–135.
37. Nadel,"Versions of the Life: George Eliot and Her Biographers," *Biography,* pp. 102–118.
38. Farrokhzad, "Vahm-e sabz" (Green Delusion), *Ketab-e Hafteh,* nos.

23–24 (27 Esfand 1962): 330–332, anthologized in *Another Birth*, pp. 117–122; Farrokhzad, "Fath-e bagh" (Conquest of the Garden), *Kayhan-e Hafteh*, no. 36 (24 Tir 1962): 136–141, anthologized in *Another Birth*, pp. 125–129, trans. Hillmann, in *A Lonely Woman*, pp. 96–99, and Farzaneh Milani in *Forugh Farrokhzad a Quarter-Century Later*, pp. 91–104; Farrokhzad, "Panjereh" (Window), *Let Us Believe*, pp. 41–47, trans. Jascha Kessler with Amin Banani, *Bride of Acacias*, pp. 105–107; Farrokhzad, "Tanha seda'st keh mimanad" (It Is Only Sound That Remains), *Arash*, no. 11 (Aban 1966): 99–102, repr. in *Let Us Believe*, pp. 74–81; Farrokhzad, "Iman biyavarim beh aghaz-e fasl-e sard" (Let Us Believe in the Beginning of the Cold Season), *Arash*, no. 9 (Aban 1965), pp. 59–68, repr. in *Let Us Believe*, pp. 9–37, trans. Jascha Kessler with Amin Banani, *Bride of Acacias*, pp. 95–102.

39. There are two issues here. The first is whether my argument goes beyond scholarship in its apparent "feminist" orientation. William Hanaway, "Biography and Farrokhzad," *Forugh Farrokhzad a Quarter-Century Later*, p. 52, states: "Forugh Farrokhzad's life and poetry are of a great interest to feminist scholars and critics. Michael Hillmann's image of Farrokhzad . . . stakes out an essentially feminist position against which there will surely be reactions from Iranian literati." Insofar as my approach, methods, and sympathy with the subject are identical in the cases of both Jalal Al-e Ahmad and Farrokhzad, the question for a male scholar such as myself is whether, if I feel and say the same things about male and female biographical subjects, I am a feminist biographer in the latter case but not in the former. The second issue is whether my argument goes beyond scholarship in its advocacy of Farrokhzad as an Iranian with the right ideals, specifically a meritocratic oppositionist stance vis-à-vis a longstanding, suppressive, and oppressive patriarchal order. 'Abdolhosayn Zarrinkub, *Az chizha-ye digar: majmu'eh-ye naqd . . .* (Of Other Things: A Collection of Criticism . . .) (Tehran: Javidan, 1977), p. 283, could have had all of Iran's history in mind when he wrote: "The truth is that if our generation, the generation of fathers, does not endeavor to know intimately the world of its sons, it is possible that this generation will unwittingly sacrifice its son as Rostam did." In the light of what Iranian fathers did to their sons in the war with Iraq in the 1980s, Zarrinkub was prescient. And in the case of Iranian families in self-exile, fathers have deprived the younger generation of its cultural heritage. The theme of

son-killing (daughters do not have the same status to begin with), which runs through Persian literature, is another aspect of this issue, given special significance in Freud's view of Islam as lacking the necessary capacity to murder its father-figures. Sigmund Freud, *Moses and Monotheism,* trans. Katherine Jones (New York: Vintage Books, 1967), pp. 102ff, 119; Hamid Dabashi, "Forugh Farrokhzad and Formative Forces in Iranian Culture," *Forugh Farrokhzad a Quarter-Century Later,* pp. 12–13.

For Farrokhzad's role as an ideal Iranian, see also Michael Hillmann, *Iranian Culture: A Persianist View* (Lanham, Md.: University Press of America, 1990). Being an advocate of hers is a legitimate scholarly enterprise, at least in the realm of biographical inquiry, which has a number of paradigms. One paradigm is interest in an individual's confrontation with life's problems. Another is learning about an age or culture through a life study. A third paradigm of biography, which structures my interest in Farrokhzad's life, is defined by Ira Nadel, "Versions of the Life," *Biography,* "an example, a model of moral and didactic value for readers." Robert Gittings, *The Nature of Biography* (Seattle: University of Washington Press, 1978), goes so far as to say: "Biography begins . . . in praise. It is also, whether openly or not, didactic praise."

40. Zhaleh Qa'em'maqami, *Divan* (Collected Poems), ed. Hosayn Pezhman Bakhtiyari (Tehran: Ebn-e Sina, 1966/7); Tal'at Bassari, *Zanddokht, pishahang-e nehzat-e azadi-ye banovan-e Iran* (Zanddokht, Forerunner of the Freedom Movement of Women in Iran) (Tehran: Tahuri, 1967); 'Alireza Nurizadeh, "Daheh-ye sha'ereh'ha" (The Decade of the Poetesses), *Ferdowsi,* no. 1005 (March, Iranian New Year's Issue, 1971): 43–46.

41. Reza Baraheni, "Farrokhzad, bonyangozar-e maktab-e mo'annas-e she'r-e Farsi" (Farrokhzad, Founder of the Feminine School in Persian Poetry), *Ferdowsi,* no. 950 (27 Bahman 1970): 20: 'Ali Akbar Moshir-Salimi, *Zanan-e sokhanvar* (Eloquent Women) (Tehran, 1956/7–1958), I, 242, quoted in Rivanne Sandler, "Change up to a Point: Iranian Women's Poetry to the 1950s," *Forugh Farrokhzad a Quarter-Century Later,* p. 39. Sandler, p. 38, argues, "In comparison to the other female poets in the collection, Forugh Farrokhzad is the most unusual in her sense of herself as an individual, in the strength of her poetic expression, and in her willingness to flout social and literary conventions."

42. Weintraub, "Autobiography and Historical Consciousness," pp. 838–839; Weintraub, *The Value of the Individual* (Chicago: University of Chicago Press, 1978), pp. xvi–xvii.
43. Russ, *How to Suppress Women's Writing* (Austin: University of Texas Press, 1983).
44. *Khandaniha* 16, no. 126 (10 Mordad 1956): 22; 19, no. 8 (26 Mehr 1958): 59–62; Hillmann, *A Lonely Woman*, pp. 12–13, 31.
45. Emami, "Recollections and Afterthoughts," p. 168.
46. Mehdi Akhvan-e Sales, "Shush-ra didam" (I Saw Susa), *Ferdowsi*, no. 1098 (December 1972), trans. Leonardo P. Alishan, *Major Voices in Contemporary Persian Literature*, comp. and ed. Michael Hillmann, *Literature East & West* 20 (June 1980): 141–143; Sohrab Sepehri, "Water's Footsteps," and Ahmad Shamlu, "Dar in bonbast" (In This Deadend), *Taraneh'ha-ye kuchek-e ghorbat* (Little Songs of Alienation) (Tehran: Mazyar, 1980), pp. 30–32, trans. Michael Hillmann, *Iranian Culture*, pp. 234–235.

4. Half-Voices: Persian Women's Lives and Letters

1. Faramarz ibn Khodadad ibn 'Abd Allah al-Kateb al-Arrajani, *Samak-e 'Ayyar*, ed. P. N. Khanlari, 5 vols. (Tehran: Bonyad-e Farhang-e Iran, 1968–1974); French trans. of vol. I by R. Razavi (Paris: Maisonneuve, 1972). See also Marina Gaillard, *Le Livre de Samak-e 'Ayyar: structure et idéologie du roman persan médiéval* (Paris: Institut d'études iraniennes, 1987); Mohammad 'Ali, Naqib al-Mamalek, *Amir Arsalan*, ed. M. J. Mahjub (Tehran: Jibi, 1961).
2. 'Abd Allah Mostowfi, *Sharh-e zendegani-ye man*, 3 vols. (Tehran: Zavvar, 1945–1947).
3. Hayden White, "The Historical Text as Literary Artifact," *The Writing of History: Literary Form and Historical Understanding*, ed. R. H. Canary and H. Kozicki (Madison: University of Wisconsin Press, 1978), pp. 41–62.
4. Susanna Egan, *Patterns of Experience in Autobiography* (Chapel Hill: The University of North Carolina Press, 1984), pp. ix–x.
5. Ira Bruce Nadel, *Biography: Fiction, Fact and Form* (New York: St. Martin's Press, 1984), p. 104.
6. Nasr Allah Falsafi, *Zendegani-ye Shah 'Abbas-e avval*, 3 vols. (Tehran: University of Tehran Press, 1953–1961).
7. Naser Khosrow, *Safar Nameh*, ed. M. Dabir Siyaqi (Tehran: Anjoman-e

asar-e melli, 1975); trans. W. M. Thackston, Jr. (New York: Bibliotheca Persica, 1986).
8. Mohammad Reza Pahlavi, *Mission for My Country* (New York: McGraw-Hill, 1961).
9. D. C. Rubin, ed., *Autobiographical Memory* (New York: Cambridge University Press, 1986).